HAUNTED CHEYENNE

HAUNTED CHEYENNE

JILL POPE

Haunted America

Published by Haunted America
A Division of The History Press
Charleston, SC 29403
www.historypress.net

Copyright © 2013 by Jill Pope
All rights reserved

First published 2013

Manufactured in the United States

ISBN 978.1.62619.158.7

Library of Congress Cataloging-in-Publication Data

Pope, Jill.
Haunted Cheyenne / Jill Pope.
pages cm. -- (Haunted America)
ISBN 978-1-62619-158-7 (pbk.)
1. Haunted places--Wyoming--Cheyenne. 2. Ghosts--Wyoming--Cheyenne. I. Title.
BF1472.U6P665 2013
133.109787'19--dc23
2013034750

CONTENTS

CONTENTS

CONTENTS

Acknowledgements

Much appreciation to all those who were kind enough to share their experiences with me.

Special thanks to: Darren Rudloff, CEO of Visit Cheyenne and Cheyenne Street Railway, who tolerates my quirkiness, and all of the Visit Cheyenne staff who are always supportive. What a great team.

Thanks to all of the Cheyenne Street Railway Trolley drivers and guides who do a fabulous job with the ghost tours: Valerie Martin, Rick Ammon, Bill Green, Ed Steinhauer, Jerry Hargraves, Debi Smith, Walt Schafer and Lloyd Rogers.

Past drivers who deserve recognition for their work on ghost tours include: David Glantz, Ron Roberson, Jake Martin, Terry Higgenbotham, Ron Summers and Larry Wall.

In loving memory of driver Gary Schaefer, we miss you, friend.

Many thanks to the paranormal investigators who have collaborated with me. From CPI Cheyenne Paranormal Investigations: Troy Brandt, Scott Newbury, Bob Acquin, Stacie Thomlinson, Troy Delois, Jessica Garcia and KH. From PITW Paranormal Investigations Team Wyoming: Jason Smith, Justin, Jamie, Chris and Ericka. Thanks also to building trustees Mike and Marriane Mansfield. From PHOG Paranormal Hunter and Observation Group: Kris and Cassie Phillips, Jose Gonzales, Arla Tibbs, Michael Gonzales, Dave Reynolds, Andrina Padilla and Manuel Gurule.

With love to all of my family, especially my adorable husband, Darin Pope, and our even more adorable children, Heather Cowley, Brady Brinton, Tyler Pope, Justin Pope and Austin Pope, and our grandchildren, Jaidyn and Hagen Cowley.

Introduction

GET INTO THE SPIRIT

Over ten years ago, I accepted a position with Visit Cheyenne, the Cheyenne Area Convention and Visitors Bureau. This is an organization that promotes tourism in Cheyenne, Wyoming, and all of Laramie County. It's a fun job as there are never two days alike, and there is always something new cooking. When I started, we operated one trolley that offered historic tours throughout the summer, ghost tours in October and holiday light tours in December. Today we have three trolleys. The Cheyenne Street Railway trolley historic tours are a great introduction to Cheyenne, telling colorful stories of the past and present. They allow the visitor to see the great attractions Cheyenne has to offer and hear of our railroad and rowdy cowboy origins. The trolleys also provide shuttles for many conventions, parties, weddings and that sort of thing.

While I always had an interest in paranormal and unexplained events, collecting stories for the ghost tours has fueled this fire. It's my favorite part of the job. The majority of the ghost tour trolley riders are local residents because October is not our strong tourist season; therefore it's important for us to offer different tours with different stories and routes each year. Our trolley drivers and I are always listening for new tales to tell. We don't make up stories for the tours but choose to only relay legitimate stories where the person genuinely believed they encountered a real spirit phenomenon. Spirits creep into our reality and reach out to us in ways we don't always understand.

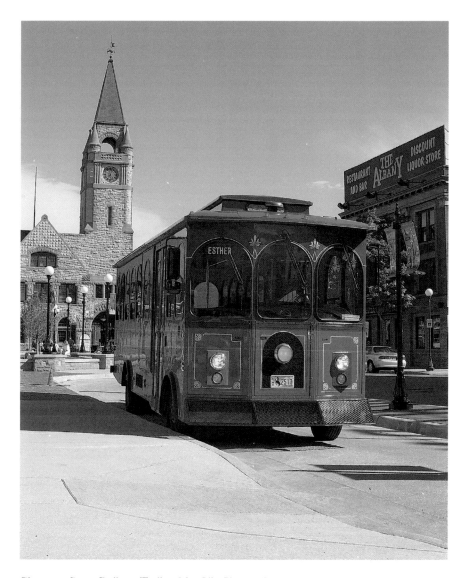

Cheyenne Street Railway Trolley. *Matt Idler Photography.*

I am often asked if I believe in ghosts. Yes, I do. I've collected way too many stories from way too many people to think it's all nonsense. I don't believe that every story I've been told is paranormal; that would be naive. There are many scientific factors that can cause strange things to happen that the normal individual may not understand. Wyoming winds can cause

their own sets of weirdness, making for unusual noises and movements. It's easy for our imaginations to get the best of us, especially when engulfed in darkness. What has been fascinating is the variety of people who share their experiences of spirits with me. These people come from every walk of life, social status, ethnicity and age. Sometimes we stereotype ghost enthusiasts as being flaky, free spirit–type personalities. This is not so. I have listened to heartfelt memories of spirit phenomena from ninety-two-year-old men; lawyers; successful executives, both male and female; store clerks; rugged ranchers; bartenders; muscle-flanked, blue-collar workers; and housewives. The list goes on and on. So yes, I believe in ghosts.

What can really spur my interest is when someone shares a ghost story with me about a location where I already have a story from someone else that this person does not know about. In some places, I have three or four separate witnesses of paranormal activity. If a story is especially intriguing, I will do some research on the specific location, and often I discover some tragedy that occurred at that very spot. This adds credibility to the events. I do this research on the Internet; at the Wyoming State Archives; at the Laramie County Library, which has a wonderful genealogy department; and county entities like the assessor's office. I will share many such stories with you in this book.

The Cheyenne Street Railway trolley began operating in June 1988. The first ghost tours were held in 1994 and were the idea of Robert Morgan and Valerie Martin, father-and-daughter trolley drivers. Their family has a passion for history, making them the perfect guides for the trolleys. They worked very hard interviewing locals and gathering stories to compile a ghost tour. They threw their hearts and souls into the tours, wearing vintage costumes and even singing ballads for the riders. The tours have always been a great success and sell out each year. Robert eventually retired and has since passed away. Valerie still drives the trolleys with twenty years under her belt. She continues to be very involved in the ghost tours, helping to gather stories and put the annual scripts together. It's very much like a theater production. There are scripts that must be timed just right for the driving span from location to location and many rehearsals, costumes and ghosts along the route. It takes the participation of all of the Cheyenne Street Railway staff. While it's a lot of work, I am confident in saying a good time is had by all.

In 2006, we partnered up with Cheyenne Paranormal Investigations (CPI), with Troy Brandt leading the group. It was a natural pairing. We shared paranormal stories with each other. I helped them with research and finding new places to investigate, and they participated in the

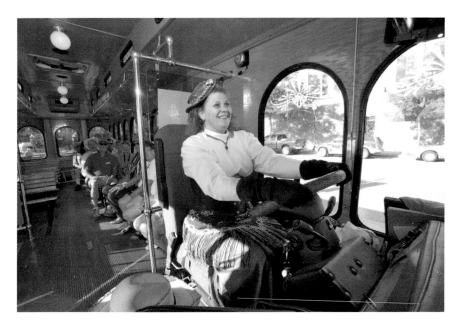

Valerie Martin giving a trolley tour. *Matt Idler Photography.*

October trolley tours. What a great bonus for the trolley customers! They got to hear about the investigations and learned about the various kinds of equipment the team uses. It's been great fun going on an investigation here and there with the team; I even got an official CPI name badge! Honestly, I don't have the stamina for all of the late-night investigations, but I love attending the initial information-gathering session with the client and seeing and hearing those video clips of paranormal activity that they collect. It takes a lot of dedication to run a paranormal investigation team. The equipment is expensive, and there are a lot of really late nights and numerous tedious hours poring through all of the collected video, watching for activity. If a person doesn't have a true passion for it, they will not stick it out. Over the years, I have worked with a few different teams, being careful to only partner with those who are level-headed and won't jump to conclusions at every sound they hear or movement they see. Other groups that I will talk about in this book are Paranormal Investigation Team of Wyoming (PITW) and Paranormal Hunting Observation Group (PHOG), with whom I am currently working. Overall, it has been a great experience collaborating with these teams.

Some people are very open to sharing their spiritual accounts, while others are a bit reserved. Therefore, some of the names have been changed "to protect the innocent" throughout the book. I would not want anyone to feel uncomfortable telling me their stories; if anonymity makes them more open, that's beneficial to me. With ten years of stories compiled, perhaps the most difficult part of the process is choosing which accounts to share with you.

I will delve into the history of several haunted locations so you have a better understanding of the spirits that reside there. Sometimes ghosts are sighted in modern buildings, and people don't understand why they would have activity there. The thing to question is what transpired at that location in the past. One day I read through the first few coroner report books from 1868, which are preserved at the Wyoming State Archives. The descriptions of deaths were very brief in the logs, but every second or third entry said Indian attack or Indian scalping. Who could blame the tribal people for trying to maintain control of their land? Most of these attacks were on the vast, open prairie, not in a home or building. Many Native Americans died on these plains as well. It was a harsh life. Native American raids on railroad workers and livestock were continuous. The military came to Cheyenne along with the railroad workers to protect them. Oftentimes when I am driving across the large state of Wyoming, admiring the beautiful mountains and prairies, I envision the wagon trains crossing through the turbulent territory. The weak did not survive. People were buried where they died. It seems logical that some of these spirits remain where they took their last breaths. Many of these resting places now have towns and neighborhoods built on them.

Its nice to think that we don't have to leave those that we love the most, that maybe there's another sphere that allows us to move on to a higher place in death, while also continuing to experience that which gave us pleasure on earth.

I.
FIFTEENTH STREET

1. HISTORIC CHEYENNE DEPOT: FIFTEENTH STREET AND CAPITOL AVENUE

Tracking Spirits

When you arrive in downtown Cheyenne, Wyoming, you're bound to notice two prominent buildings that rise above the others. One is the elegant, gold-domed Wyoming state capitol building, and nine blocks directly to the south is the historic depot with its steeple clock tower. The buildings face each other, and it is said they were built this way so the government and the railroad could keep an eye on each other. Both buildings are said to have resident ghosts.

I have the privilege of working in the depot. This wonderful building actually sat empty for years after Union Pacific moved its offices out. It narrowly escaped the wrecking ball, only to be skillfully renovated and then designated and protected as a National Landmark. There are about 2,500 National Landmarks in the United States; the depot finds itself in the company of Pearl Harbor and the Ryman Grand Ole Opry.

My office is located on the second of the three floors. My company also operates a tourist visitor center in the lobby. Besides Visit Cheyenne and Cheyenne Street Railway Trolleys, the depot also houses the Greater Cheyenne Chamber of Commerce, LEADS (an economic development

The Cheyenne Historic Depot and Plaza. *Envy Photography.*

entity), the Cheyenne Depot Museum, the depot management offices and Shadows Brew Pub, along with all of their attached ghosts.

When Cheyenne was originally established in 1867, a small wooden depot was built at this location. A decade later, that depot was dragged off to the side with a steam engine, and this prominent brick building was constructed. Standing in the lobby, you can feel the history the building emits. Famous author Ernest Hemmingway married his third wife, Martha Gelhorn, in Cheyenne in 1940; they celebrated their nuptials at the formal and prestigious Hick Hall restaurant, located in the east wing of the depot. Shadows Brew Pub is there today. The past lingers in the depot, where layers on layers of history have lived.

As with any long-standing rail yard, there were serious injuries and deaths in the early period. I have found documentation of some deaths here in old newspaper editions at our Wyoming State Archives. In 1910, a yard watchman had been run over by a train, and his remains were gruesome and mangled. Over one hundred years have passed since a shot rang out in the rail yard; it was 1:45 a.m. on August 5, 1912. Union Pacific watchman LJ Sparr, age twenty-nine, was murdered while monitoring vagrants to prevent boxcar robberies. An hour later, his body was found in the darkness, just beyond

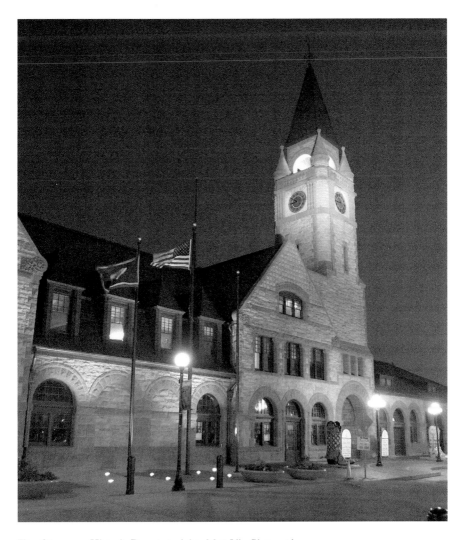

The Cheyenne Historic Depot at night. *Matt Idler Photography.*

the depot between the number one and two freight tracks. The murder was about seventy feet from where the other watchman had been run over two years earlier. Sparr had been shot at close range from behind, evidenced by powder burns below his left ear. The assailant stole the guard's gun after killing him but did not take his wallet, leaving investigators to question whether the aggressor had been a frightened hobo or someone with a more sinister motive. Conductor William Walcott had seen Sparr with a stranger

around midnight walking alongside his train. Known as a swift man with a gun, Sparr was very cautious when handling hobos, never allowing anyone to get behind him. Since Sparr had previously been employed at the state penitentiary in Rawlins, it was thought the killer might have been a former inmate. This theory proved true three weeks later when Charles Taylor admitted to killing Sparr. Taylor had served time at the state penitentiary when Sparr worked there. He was considered an evil man.

The next incident involves a woman of questionable morals who lived three blocks north of the depot on Eighteenth Street. She contracted a disease from a miner after having relations. The man refused to help her with the matter. On October 27, 1935, she waited for him at the depot. When he got off the iron horse, she fatally shot him four times.

The most notorious death here was that of Charles Bernard, the Wyoming Division superintendent for the Union Pacific. Charles was casually leaning against a cigar stand chatting with the clerk when a disgruntled employee entered the depot. Without saying a word, he fired three shots at Charles. Charles died instantly, falling to the floor with two bullets in his head and one in his back. The shooter, Perry Carroll, then turned the pistol on himself. He landed beside the superintendent, writhing in pain, but he survived. It turns out that Perry Carroll was a switch tender who had been fired a month earlier for being drunk on the job. He caused such a commotion when he was terminated that the police were summoned, and he was arrested. The murder was premeditated; Carroll had written a letter to his family in Texas telling them his train of thought. Carroll went on trial with an insanity defense. He was sentenced to die in the newfangled gas chamber. The smiling Carroll was executed a little after midnight in August 1937, on Friday the thirteenth.

Charles Bernard had begun his position as the division superintendent on the very same day that another man was shot down in a rail yard shop across the tracks, east of the depot. The *Tribune* newspaper noted that Barnard's job started with a shooting and ended with another—his own. In the heat of the Great Depression, like many in that hard economic time, Keith Bellars was relieved of his position as receiving clerk. After stewing for two days, Bellars withdrew all his money from the bank and purchased a pistol. Determined to settle the score on this fateful day—another Friday the thirteenth, this time October 1933—Bellars brandished his loaded gun at "the store" with the intent of shooting division storekeeper R. Mullens. Fortunately for Mullens, he had stepped out. Bellars impatiently paced back and forth outside of the shop, and when he couldn't contain himself any longer, he burst into

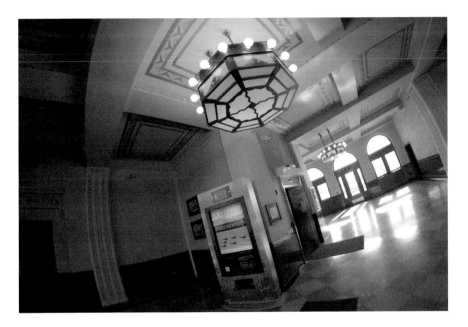

Cheyenne Depot lobby. *Envy Photography.*

the shop, randomly firing off his gun as he fiendishly hollered, "I've been double-crossed!" R.H. Fasen was hit twice in the abdomen and suffered an agonizing demise. Chief clerk Floyd Watson was also wounded but would recover. Bellars ran, though he ultimately surrendered to a policeman. He was tried for first-degree murder, found not guilty by reason of insanity and committed to the Wyoming State Hospital in Evanston. Daringly, he escaped but was quickly recaptured. It's hard to say if the strange noises and eerie feeling in "the store" at night are just products of a creaky old building and the night rail yard environment or if Mr. Fasen lingers on.

With all of these atrocities, it's no wonder there are many accounts of paranormal activity here. It was dead quiet on one snowy January afternoon. Lauren was seated at her computer in the depot visitor center when she heard a child's laughter. This caught her by surprise because she thought she was the only person there. No one had come through the doors. She stood up and looked around but did not see anyone. She heard the laughter again, so she exited the visitor center and walked out into the lobby area, checking the cut-out area that once housed the ticket counter. No one else was in the lobby, but she clearly heard the laughter in the cut-out area.

Lindsey, the depot event coordinator, is sometimes responsible for securing the building after events. Lindsey and her husband have been hearing giggling in the lobby at night when they are the last ones in the building. They also hear things falling and crashing in the cut-out. While checking out the sounds, her husband once felt something blow on his neck. After working in the depot and experiencing these things, Lindsey and her husband joined a paranormal investigation group. She reports that they all saw a black figure of a woman in the same area.

On a calm summer night, Joe was closing up the building. He was alone in the quiet lobby and had already locked the glass front doors. He strode across the room to the opposite end

Depot lobby taken during PHOG's investigation. *Jose Gonzales.*

of the lobby near the elevator. It was then that Joe witnessed the interior set of glass doors swiftly open of their own accord. They had been fully closed, and then he saw them unfold to a wide-open position. The exterior set remained closed and locked. There were no drafts, and the wind was not blowing outside.

The Cheyenne Depot Museum is located in the west wing of the building. There are frequent spirit encounters here. When the depot was first renovated and reopened in 2003, there were still a number of small construction projects to be done. One evening, Jim was closing up the building, and Candi was counting the gift shop money drawer. Jim had completed his closing routine inside, so he exited the depot and was doing an outside security walk before heading home. Candi was surprised to see a man inside the lobby; she knew the doors had already been locked. The man was wearing raggedy jeans and a tattered baseball cap. A bit unnerved, Candi spoke to him, asking where he had come from. He said he'd been working upstairs doing a painting job. Before she knew it, he was simply gone, right before her eyes. She had not unlocked the door to let him out. Frightened by her experience with the hereafter, Candi quickly left. The next morning when she spoke to Jim about it, he informed her

that there had not been any painting crew upstairs for a month, and he was certain that no one was inside the building when he locked it.

During the late hours of the night, when the building is dark and empty and the security system armed, merchandise has been rearranged in the gift shop. All the lights have come on, chasing the darkness away. In the morning, the staff arrives and finds things out of place, but the doors are still locked and the alarm is still on, leaving them to wonder how things could have been altered. The gift shop manager once saw a pair of earrings fling off the counter. Lindsey says that she has seen the silhouette of a shadow man in the gift shop numerous times. She feels that the whole depot comes alive at night, as if it's a busy functioning train depot with spirits afoot.

Joe had a spine-tingling brush with a presence on the upper floor of the museum. He heard a loud knocking sound. Concerned, he called out, but no one answered, so he carefully ventured closer to the sound. Once he decided there was no one there, he turned and walked toward the exit, but as he approached, he became overwhelmed by a foreboding feeling. All his senses alert, he felt the hair on his arms and neck stand on end. Something unseen was there. Joe shut the doors and briskly walked away. He jumped out of his skin when there was a **LOUD** bang.

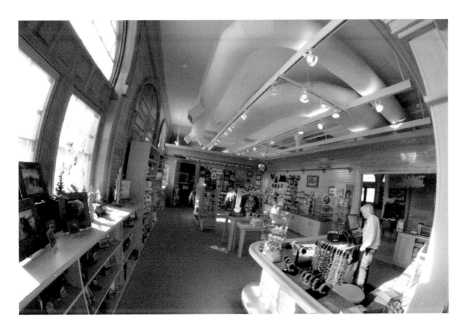

Depot gift shop. *Envy Photography.*

There is a large scale on the main floor of the museum where baggage would be weighed, and a pulley system was in place to draw the heavy trunks up through a hatchway into the second-floor baggage storage area. Members of the Paranormal Hunting Observation Group (PHOG) said they saw a light shining through the hatchway that they couldn't explain. All the lights were off on the second floor, and no one in the group was up there. They went upstairs to see if there was any light up there that could shine down, but there was not. They tried recreating the light with flashlights and switches but were not able to reproduce the same thing. They felt it was unexplained and inconclusive.

Garrett worked his first summer job at the depot. It was a good gig for a fifteen-year-old. The job was simple enough: he ran the model railroad trains and watched over them in the second floor of the depot museum. Late one afternoon, he had finished his shift and was dragging himself down the historic staircase to go home. That's when he felt someone give him a solid push. It wasn't enough to send him tumbling, but he definitely felt a full hand give him a shove. Abruptly, he turned around, only to find that he was the only person in the stairwell. Garrett hustled down the rest of the stairs and escaped into the populated lobby.

Baggage hatch taken during PHOG investigation. *Jose Gonzales.*

Depot basement. *Envy Photography.*

The basement seems quite fitting for a ghost dwelling. Portions of it still contain dirt floors and walls. There are several staff members who will not go into the basement, at least not by themselves. A white misty figure has been seen, and there are reports of crazy noises and things being moved. A blue-collar worker from another realm has been sighted in the building on numerous occasions, most often in the gloomy basement and stairwell that descend from the museum.

There are many events such as weddings and festivals held at the depot, inside and out. Andy works these events setting up and taking down. Andy is a religious man who would give you the shirt off his back. The tables and chairs are stored in the basement, so Andy spends a lot of time down there. He has witnessed unusual lights in a small room off the main hallway. Oddly, there is a small window cut into the concrete wall in a room to the side of the elevator. This is simply cut out; there is no glass. Andy and other employees get a strong feeling there is something ominous there in that hole. Sometimes he notices a heavy creosote smell.

A few high school kids had performed at the depot with their school orchestra. They were visiting with Andy, asking him about ghosts in the building. He offered to give them a tour of the basement. The bleak hallway is very narrow, and Andy was leading. The last boy in the line shrieked. A

Hole in the basement wall. *Jose Gonzales.*

rock had hit him in the back of the head. There was no one behind him to throw the rock. Another evening, Andy and another man were riding the elevator up. All of a sudden, the elevator was filled with a strong creosote stench. Then the elevator lurched to a stop, and they were stuck between floors. After trying to make a call, they began screaming, but no one was in the depot. Finally someone at the attached Shadows Brew Pub heard the commotion and got them assistance.

A former Union Pacific employee who worked there in the early 1980s spoke of ghosts in the building. Footsteps were heard on the second floor, and some people refused to work there. I often think I hear someone working on the other side of the partitions in my second-floor office, but when I speak and don't get a response, I walk over there to discover I am alone in the office. Most of the women feel there is some presence in the ladies' restroom; you never feel alone in there and hear sounds of another person moving around when you are alone. There is a boardroom that is used for many meetings by the tenants and community members alike. A paranormal investigation team saw items slide across the table,

and Lindsey heard a can slide across the same table. She also often hears voices and groans in there. This space used to be the office of the Union Pacific superintendent.

The railroad is the reason that Cheyenne exists. When the rail workers made it as far as Cheyenne, they set up their tents a few blocks from where the depot stands today. The nickname "Hell on Wheels" referred to temporary towns that were quickly set up as the tracks were being built. Most of their makeshift buildings were saloons. The pre-fabs came with immense bars, complete with libations. The bartender was set up and serving whiskey shots before the roof was even set on. Gambling tables were laid out, and saloon girls were in position, brandishing derringers in their garters for protection. Once the tracks were finished, the saloons were easily disassembled, loaded back on the train flatcars and moved to the next site to be reassembled. Some of these town sites survived, and some did not, but Cheyenne thrived.

Shadows Pub and Grill

The east wing of the depot houses Shadows Pub and Grill, a present-day saloon, in a building from another time. Most of the staff has experienced paranormal activity here. One night, Jeff, the manager, and Kendra, a waitress, were doing their normal closing routine. The kitchen door began banging, which naturally concerned Jeff, but Kendra simply said, "It's him again." When Jeff questioned her as to who she was referring to, she said it was a railroad guy, and she saw him all the time. Not understanding that Kendra was referring to a ghost, Jeff inspected the kitchen area. He did not see anyone but wanted to make sure a vagrant was not in there. Once satisfied, he went about his tasks. They had stacked all the chairs up on the tabletops when they heard loud banging sounds again. Kendra said, "There he is!" Jeff could not see him, but Kendra could. "Didn't you just see him?" she asked. At that time, two chairs from two different tables crashed to the floor. If they had fallen from the same table, Jeff may have thought that they had not been placed squarely on the table, but there was no reason for chairs to fall from two different areas. They hightailed it out of there.

Kendra is obviously more sensitive to spirits than the average person. On occasion, she has seen the apparition of a little old man with a beard near the men's room door. Jeff went into the empty restroom and shuddered as he watched the toilet paper rolls spinning out of control. They considered that the old man spirit might be behind it. One day, a collection of several

Left: Shadows Brew Pub located in the historic Depot building. *Matt Idler Photography.*

Below: Shadows Brew Pub. *Matt Idler Photography.*

chairs and tables moved on their own right in front of several staff members, making them all believers.

Working after-hours one night with all the doors locked and all of the customers gone, Jeff had finished cleaning up the entire bar area. He descended into the basement for supplies. When he returned, he found a lone shot glass overturned on the bar. There was a small amount of liquid under it, and an old buffalo quarter lay beside it, presumably from a patron of another time.

2. HOFMAN BUILDING: DEPOT STREET MERCHANTS, 316 WEST FIFTEENTH STREET

Red Light Resting Place

Fifteenth Street is the first street north of the tracks in the former red light district. It is the road where both the depot and the Hofman Building are located. Depot Street Merchants, currently a local beer home brew supply store operates from the Hofman Building. This building is the second-oldest commercial building in Cheyenne. The cornerstone dated 1872 is situated near the door. Once inside, you will find a collection of home-brew supplies and collectable beer steins, displayed on beautiful antique shelves. The building retains many of its original features, with fourteen-foot-high beadboard ceiling. In an interview with the owner, I learned that it was built by the Hofman Brothers as a saloon, gambling hall, bordello and boardinghouse simply known as Hofman House and Bar. Tom Horn, who was hanged for shooting fourteen-year-old Willie Nickel back in 1903, was known to frequent this saloon. It later housed Neef Brothers Beer in 1912 and a restaurant from 1919 to approximately 1926. After that, Boyd's Cigar and Candy Warehouse was located there and owned and stocked five different cigar and drugstores in Cheyenne out of this warehouse. I spoke to a few folks that recall Boyd's. One worked there loading the trucks as a teenager, while another remembers going in there and delighting in the large containers of candy on hand, a fond childhood memory.

One of the Boyd's employees bought the business and then sold it to the current owners in the early 1970s. For nearly forty years, this same family has occupied the building, using it for a variety of purposes. Over that time, the owners have encountered some curious things. My first visit to the

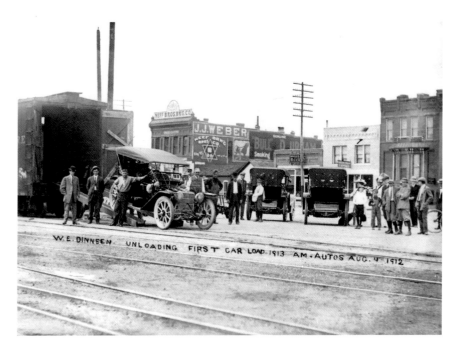

Neef Bros. Brewing Co. is shown on the left in 1913. This is now the Depot Street Merchants. *Photo from Wyoming State Archives, Wyoming Department of State Parks and Cultural Resources.*

Hofman Building was in the mid-1980s. By then, the owners already knew they were not alone within these walls. On many occasions, footsteps are heard from overhead when no one is on the second floor. The family had a large Rottweiler dog that often accompanied them to the shop. If the dog went into the bathroom, it would react, raising its hackles and growling as if it were confronting an adversary. Later, another family member brought in his silky terrier only to find that it reacted the same way. Further validating a presence here is the fact that this toilet continually flushes on its own, with no explanation to be found.

The Union Pacific signal department is located directly across the street. Some of the Union Pacific Railroad workers came into the store one day and asked if the employees were aware that the building was haunted. They reported watching strange occurrences in this building. At night, they can see the hanging lights swaying uncontrollably back and forth, as if in an earthquake. Through the second-floor windows, they would see lights turn on, which is particularly disturbing because there is no electricity upstairs.

One of the owners in the family was giving a friend a tour of the building. They went upstairs to look around as he relayed stories of its vibrant past and resident ghosts. He reached out to open a door, but as his hand neared the door, the doorknob turned before he touched it. He pulled back as they both stared in awe. This affirmed the comments he was just making about the building being inhabited by ghostly beings.

Another family member would bring her young daughter with her to the Hofman building, where she operated a woodworking business. One day the girl brought a helium balloon with her and was upset when it got away from her and floated up to the high ceiling. Her mom figured that it would float down by morning as the helium began to deplete. The following day, they searched high and low, but the balloon was nowhere to be found. The girl said, "Maybe Peter took it." She explained that he was a boy she played with when they were there. Her parents weren't sure if this was the normal imaginary childhood friend or something more, but their daughter frequently spoke of him. Weeks later, the balloon was found: it was between two counters and was somehow still fully inflated. It was way too big to fit in the small space between the counters, and they couldn't understand how it got into this space or how it had still not deflated.

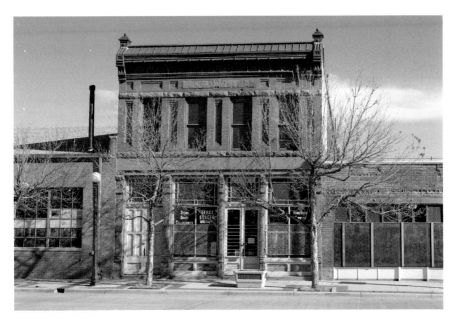

Hofman Building. *Jill Pope.*

At times, items would unexplainably fall off of shelves. Some items were hung on teacup hooks reinforced with string. One example was a birdhouse that was found on the floor; the string was not broken, so how did it get off the hook? Another item was a Corona parrot that was shattered on the floor, also with the string intact. The owners questioned how these items and the strings could have lifted up over the curve of the hook to fall onto the floor. The terrier dog would also react in the corner where this birdhouse hangs.

One day, a stranger came into the business and boldly asked to go upstairs to talk to the ghost. The owners were taken aback, but they let him go upstairs. He was up there for over an hour. When he came down, he described three ghosts that he said were attached to the building, labeling them as a mean man, a girl and another small child. He claimed that the young girl was murdered there and is buried in the building. He feels this is now her resting place. Understandably, the owners weren't too sure what to make of the fellow. There have been frequent encounters here, and many people have seen and experienced unusual things in the building over the years, but there's no evidence to back up this man's claim.

LINCOLNWAY, WEST 100 BLOCK

3. HISTORIC PLAINS HOTEL: LINCOLNWAY AND CENTRAL AVENUE

Rose from the Dead

Lincolnway is the main street going through town. Originally, it was called Sixteenth, as the streets run in numerical order. The Lincoln Highway was established one hundred years ago, and Sixteenth Street is a small portion of the extending Lincoln Highway. In time, this street became known as Lincolnway, but it is sometimes still referred to as Sixteenth Street.

Situated on busy Lincolnway Street, across from the Depot Plaza, is the "Grand Ole Lady of the Plains," the renowned Plains Hotel, built in 1911. This five-story blond brick building featured opulent rooms adorned with velvet curtains and plush carpet. It was the first building in Cheyenne to have telephones installed during construction. In 2002, the historic property underwent a multimillion-dollar restoration to bring it back to its original glory. There is an exquisite stained-glass atrium dome in the main lobby and beautiful woodwork in the restaurant and lounge. The prominent hotel has great history from the past one hundred years. If only those walls could talk! I have a photocopy of an invitation to attend Thomas Edison's demonstration of his new disc phonograph, held in the tearoom at the Plains Hotel, dated 1878.

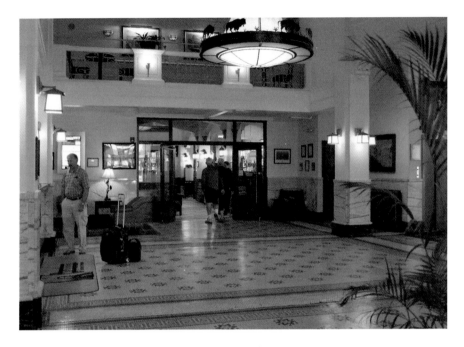

The Historic Plains Hotel lobby. *Matt Idler Photography.*

Among the many guests who enjoy staying at the lovely historic hotel are a fair amount of paranormal enthusiasts who anxiously book rooms there hoping for some spirit to make itself known. The hotel is notorious for its ghosts, all of "good spirit." There have been sightings on every level of the hotel. I will share both the commonly known stories and recount some others that have not been published before.

One story has been circulated for many years of someone falling from a fourth-floor window. There are many versions of this tale. Some say the man jumped, while others say he was pushed. A hotel employee told me it was a teenager who jumped. Many ghost-themed websites mention the death, but no one really has any specific details. There is definitely spirit activity happening on the floor, however. Over the years, occupants of room 444 have experienced moving furniture, self-locking doors, the odor of cigar smoke and appliances that turn themselves on and off at will. Room 426 is the first suite near the elevator. Strange noises come from the closet, and belongings get moved around in there. Christy was the manager on duty, and she was once walking down this hallway and noticed that a lady leaving from room 426 had an odd look on her face. Christy inquired if all was well.

The lady retorted, "I will never stay in that room again!" Christy began to apologize as she delved into the nature of the problem. The lady said that she liked the hotel and would gladly stay again, just not in that room. The woman traveled quite a bit and collected pinecones along the way. She had selected the perfect pinecone the day before and had placed it on the desk before retiring for the night. When she woke up, the pinecone had been smashed completely flat, still lying on the desk.

There are two different stories involving a young boy's demise. It is said that a young boy fell down the dumbwaiter from the fourth floor, plummeting to his early death. Another recount is that of a plumber who had been contracted to work in the basement many years ago who allowed his son to tag along with him. A pipe came swinging down on the child, smashing the life from his delicate body. There is a spirit of a young blond boy around the age of eight often spotted in the basement and in the lobby near the grand piano. He has a Dutch boy haircut and is wearing a white shirt and dark shorts with tall white knee socks. He is there one moment and gone the next. The little boy has sometimes been seen playing in the hotel lobby, and many times the staff has had to shush him because he is making too much noise.

Another grim tale of the building involves a death plunge from the fifth floor. The *Wyoming State Leader* from March 6, 1924, read, "The grim spectre of drugs hovers over the corner of Lincolnway and Central Avenue." The article speaks of the splayed-out body of forty-three-year-old Fern Blaylock, who landed on the street. She was a beautiful, wealthy society matron from Denver. "She dropped to her death from the fifth-floor window, lured from the tantalizing hallucinations of drugs." Three people who were working across the street reported that Mrs. Blaylock had been seated at the open window of room 530 for some time, staring down at the sidewalk below her. She eventually moved onto the window ledge, and soon Fern was dangling there, her hands gripping the windowsill. Her hold soon gave way, and flailing down, she struck the sidewalk with tremendous force. The coroner said Fern was under the influence of Veronal, a sedative that could be obtained at nearly any pharmacy. Fern was a former Denver model and wealthy socialite. Five months earlier, she had divorced a successful attorney and oilman from Casper, Wyoming, on the grounds of cruelty. She was awaiting the decision of a civil lawsuit against her ex-husband over oil land. There was a coroner's inquest, and the jury rejected the notion that Mrs. Blaylock's death was murder, as her attorney suggested. A scribbled farewell note had been found in her room.

A manager tells me that 911 was continually called from an empty room on the fifth floor over eighty years later. This continued even after the phone was taken out of the room. After a few days, it suddenly stopped.

Christy was having dinner with her friend Sue at the hotel. Sue's face turned to stone, and Christy actually feared that she was suffering a stroke. Alarmed. she grabbed Sue's arm, saying, "Are you OK?" Sue asked if she had seen the cowboy that just walked past them. He was translucent, and she could see right through him. Other guests have mentioned waking up to find a cowboy sitting on their bed, but then he vanishes before them.

Room 310, in particular, is said to be haunted. The housekeeping department complains that a spirit messes with the items on the maids' carts.

The basement of the hotel is mainly used for storage. It's like a museum down there, and interesting articles of the past can be found in all the nooks and crannies. Jake, a friend of mine, lays carpet for the Plains Hotel, which stores the excess carpet in the basement. Red, a custodian, recounted to Jake that he had seen a man in the basement. Wondering who would be down there, he followed him, and the stranger went into a room that had once been a barbershop. When Red entered, no one was there. There are no exits from the room other than the doorway Red was blocking.

Jake started to venture down a long, dimly lit basement hallway when a woman doing laundry cautioned him, "I wouldn't go down there," stating that it was haunted. Familiar with the eerie space, she escorted him down the long hall, they came across an easy chair with a disheveled sheet lying across it. Next to the chair was a pack of cigarettes, cards, a lighter and some coins. She said that previously the staff had straightened the sheet and picked the items up, but whenever they'd return, they would find the items exactly as they were before they touched them. Oftentimes, the employees smell cigarette smoke. The spirit has been here many years, but they don't know who he is.

Late one night, two repairmen noticed an older woman sitting in the bleak basement. She was sewing and did not acknowledge their presence in any way. She stood up and turned around, but then she sat back down and resumed her sewing. Finding this very unusual, they went up and told the front desk staff about the woman. The staff said that there wasn't anyone else downstairs. When they returned, she had vanished.

A few years ago, Ruby and her boyfriend had gone to Chocolate Indulgence, a decadent annual event. Afterward, they decided to go for a drink at the Plains Hotel. They both went into their respective bathrooms. She heard him sneeze through the wall, and since no one was around, she loudly said,

"I can hear you!" Soon after, she heard the door open and saw a figure in black walk past through the spaces between the bathroom stalls. She thought her boyfriend was sneaking in and was going to scare her. When she went to wash her hands, she looked into the mirror to see if he was there. All of the stall doors were opened, and he was not there. In fact, no one was there, so where had the black figure gone? It could not have moved past her without her seeing it. She went out and asked her boyfriend if he had come in, to which he replied, "No, I wasn't in the ladies' room!"

In May 2009, there was an annual corporate retreat being held at the Grand Ole Lady of the Plains. One of the women in the

Possible ghost photo given to the hotel by a guest. *Photo provided by Historic Plains Hotel employee.*

group went into the public restroom on the second floor, but she frantically came running out of the restroom, shaken up because she had seen a female ghost. She refused to go back in. Christy went into the same restroom, noting that she was alone. It surprised her when she heard a woman sigh heavily. *Oh, there is someone in here,* she thought, but there were no other sounds whatsoever. Curious, Christy looked underneath all of the stalls, but there were no feet. Liz, a hotel employee, has seen a female apparition here.

Bob said that in August 2007, he was working on a computer in the sales office on the second floor. He heard the office door open, and he heard and felt footsteps, but looking up, he realized no one else was there…that he could see. He definitely felt the presence around him, though. Christy's desk was situated near the sales office door. The other administrative staff members' desks were placed farther back in the long room. The other staff kept hearing a woman humming. Christy thought they were crazy, as she never heard it at her desk, and she teased them about it. One day, they all got up from their desks and investigated all the surrounding rooms. They even went upstairs and checked the room above their office but found no

explanation. As July is Cheyenne's busiest tourist month, Christy was still at work at 9:30 p.m. and was relieved to have the office to herself to try and catch up. Then the humming started right behind her. She tried staying on task, but it just kept on. Christy turned up the music and said out loud, "I don't have time for this." The humming got louder and louder and louder. This was more than she could take, and agitated, she swiftly left.

Young girls dream of their wedding day for years, planning out every detail in their minds. Rose was a happy bride, and she so loved her groom. They were spending their wedding night at the new lavish Plains Hotel, which was so beautiful to behold. They were making a life together and would soon be starting a family. The couple said their vows that very afternoon, committing to love, honor and obey each other as long as they both shall live. The couple settled into their second-floor hotel room. Rose's new husband liked his cigars and whiskey. He politely excused himself and went downstairs to indulge in his habits without disturbing his new bride. Rose became antsy, as he was taking too long, and it was their wedding night, after all. She walked down the hallway to the mezzanine. She could hear the orchestra playing in the lobby, and she peered over the balcony to the main floor looking for her groom. She spotted him—but he was not alone. Rose could not believe her eyes when she saw that he was consorting with a cheap lady of the evening. They were newlyweds; how dare he! Enraged, she watched as they left the area, and quietly she followed them up to fifth floor, where her cheating husband, still in his coat and tails from their wedding ceremony, and the prostitute, wearing a revealing red dress, entered a sleeping room. Devastated, Rose ran back to her own room. Crying, she threw herself on the bed. She was so hurt and angry, and that's when his gun caught her eye. *Until death do us part,* she thought. In an angry rage, she made her way back to the tramp's room. There she found her groom in the arms of another woman. The shots rang out; two bloody entwined bodies lay across the bed. In a distraught haze, Rose went back to her honeymoon suite and turned the gun on herself, ending her own life, so full of sorrow and wishing for a life that should have been. (*Note:* Some accounts say the prostitute's room was on the fourth floor.)

Rose is still heard wailing on the second-floor room, all alone. Both laughter and crying are heard at different times of the day outside of her room, but when the door is opened, no one is there. Rose has been seen in a long blue gown, walking from wall to wall on the second floor, presumably where doors used to be before the hotel was renovated. Her cheating husband has been seen all over the hotel, from the fifth floor to the basement. Is he

trying to return to his lonely wife or the vixen in red? He is seen in his formal wedding attire: a decorative silver button near the collar of his white dress shirt, a long-tail black dress coat, black pants and black boots.

Another feminine spirit flaunts herself on the second floor, dressed in a daring, short red dress with white lace, presumably the lady of the evening that was killed on that fateful night. Several years ago, the lobby was decorated for Halloween. One of the scenes included mannequins dressed in wedding clothes. A front desk associate looked up and saw the provocative spirit in her short red dress looking down at the wedding figures, and just then, the mannequin in the wedding gown toppled over. Astonished, the associate glanced down at the fallen mannequin, then back up to the harlot, but her spirit was gone.

Vicki was being trained for her new position at the hotel by an older gentleman. It was two-thirty in the morning, and they were on the second floor. Suddenly she felt a cold chill move through her. The prickling hair on the back of her neck was standing on end, and she was overcome by an ominous feeling, all of her senses at high alert. She felt really apprehensive about continuing down the hallway, and embarrassed, she expressed this to her new supervisor. It was then that he told her of Rose. On several occasions while working the night shift, Vicki would catch a glimpse of movement across the second-floor mezzanine balcony. She also noticed the flags that hung inside from the balcony waving as though there was wind blowing.

III.
LINCOLNWAY, WEST 200 BLOCK

4. WRANGLER WESTERN STORE: SOUTHWEST CORNER OF LINCOLNWAY AND CAPITOL AVENUE

Boots and Boogeymen

In 1870, a massive fire referred to as the "Great Disaster" destroyed seventy businesses, and all but one building in this block and the next block west burned down. Fire was a severe problem in Cheyenne's early days. The buildings were constructed of wood, there wasn't a big water supply and the climate here is very dry, plus the wind is known to blow here on the wide-open prairie. Twelve years later, the landmark Wrangler store went up on the corner of Capitol Avenue and Lincolnway Street. The building has been painted a bright barn red for years and is easily recognized. The sign boasts, "Famous for Ranchwear since 1943." Before becoming the Wrangler Store, it housed the First National Bank, the Normandie and the Edwards Hotels and a couple grocery stores.

In 1911, wealthy stockman Mark Coad was living here when it was the upscale Normandie Hotel. There was plumbing and gas in all the rooms, quite a luxury at that time. Despite the elite surroundings, he was murdered inside. Sentenced to twenty-five years, the convicted murderer, F. Corrida, hanged himself at the state penitentiary in July 1912. There are still many remnants of the time when this building was an upscale hotel; the upper

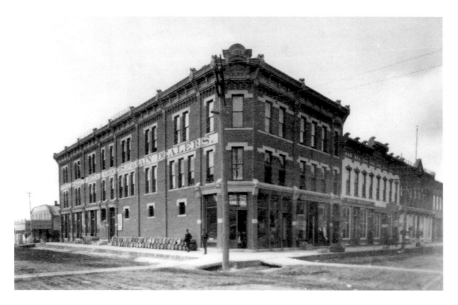

The Phoenix Block rose from the ashes. *Photo from Wyoming State Archives, Wyoming Department of State Parks and Cultural Resources.*

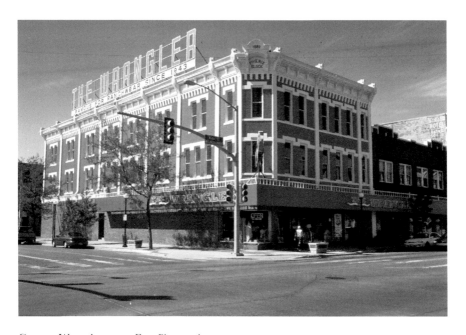

Current Wrangler store. *Envy Photography.*

floor is divided into twenty-seven hotel-size rooms, with wallpaper peeling down from days gone by. A long-term employee said she physically felt a cold entity attach itself to her back, and terrified, she ran down the hall and down the stairs. There have been sightings of a ghostly older couple up there. The manager had her office upstairs for a number of years, and she admits there were many times when she would hear someone coming up the stairs and walking down the hall, but when she would look, no one was there. A century ago, a wife caught her husband cheating. Driven by despair, she went to her boarding room upstairs at the Normandie Hotel and ended her life. She has been heard wailing throughout the building.

A young couple walked into the store, but a few feet in, the lady abruptly stopped with a perplexed expression on her face. Looking all around, she gradually inched her way in. She bluntly asked the salesman if they had a lot of unexplained things happen there, going on to say that she was overwhelmed by the spirits here, especially that of a young boy about five years old. She said he was very active and mischievous. There were family rooms in the rooming house upstairs, so it is entirely possible to have child spirits here. Employees have seen the spirit of a little girl in the store.

Employees always keep the radio tuned to a western station, as that's the nature of their business, but sometimes the radio is unexplainably

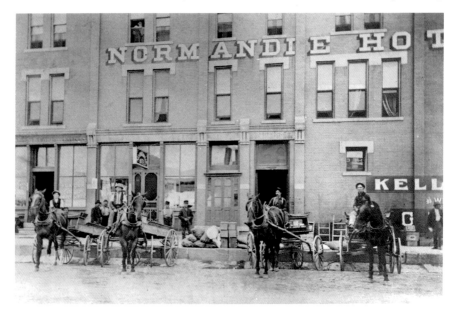

Normandie Hotel, now the Wrangler store. *Photo from Wyoming State Archives, Wyoming Department of State Parks and Cultural Resources.*

 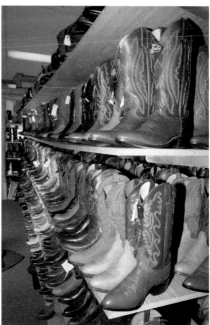

Left: Hat steamer in the Wrangler store. *Matt Idler Photography.*

Right: Rows of cowboy boots at the Wrangler Western Store. *Matt Idler Photography.*

playing Latino or hip-hop music. The manager was annoyed when this first happened. The master switch is way in the back and is not easy to access. She approached her employees about the station changes, and they all adamantly denied touching the radio. She believed them, but the problem persists. The music goes on and off on its own sometimes. The hat steamer also powers itself up and down.

Two of the charming young cowboys that work at the Wrangler were standing near the front of the store conversing when a plastic sign placed on top of a clothing rack shot clear across the room. There was no airflow to cause this. The guys were seriously taken aback.

The scent of leather entices you before you even enter the store. The boot department has a great selection for the customers. Row upon row of boots are lined up by size for the customers to peruse. A couple employees once noticed a set of three boots shaking dramatically while all of the surrounding boots remained perfectly still. The employees were transfixed. This lasted several seconds, and then stopped as suddenly as it started.

A few employees have told me that they hear rattling chains from the basement. When the women go into the basement, they sometimes get whistled at. A cowboy ghost comes up from the basement. He is seen meandering around the main floor and then wanders up to the second floor, making his rounds. Some of the staff have seen a form flee through the store, something that's not human.

5. HYNDS BUILDING: NORTHWEST CORNER OF LINCOLNWAY AND CAPITOL AVENUE

Inferno Impressions

From 1875 to 1916, the northwest corner of Capital Avenue and Lincolnway, directly across from the Wrangler store, was the site of the lavish Inter-Ocean Hotel. It was built by Barney Ford, a slave who escaped to freedom on the legendary Underground Railroad. Barney's mother was a slave and his father a white plantation owner. In its heyday, Presidents Ulysses S. Grant and Teddy Roosevelt visited the decadent hotel.

On December 17, 1916, a sizzle in the wiring resulted in a blazing fire. Most buildings didn't have fire escapes in that day. One man, Roy White, left his wife, Ethel, and four children behind to perish when he jumped from a third-story window to escape the roaring flames, only to be electrocuted when he landed on an electrical wire outside of the hotel—poetic justice. Unfortunately, the other five family members succumbed to the inferno.

The remains of the Inter-Ocean were unstable and had to be razed. Harry Hynds purchased the property. With the debris cleared, the premier five-story Hynds Office Building was put up. The white stone structure was designed to be fireproof and, so far, has stood the test of time; the Hynds Building remained unscathed when the neighboring two buildings burned down in 2004. Harry Hynds was a blacksmith who was also a shrewd gambler. Harry drove the Cheyenne–Black Hills Stage during the gold rush, and it departed from the Inter-Ocean. Cheyenne was Wyoming's main gateway to the Dakota gold fields. In 1883, Hynds took over the blacksmith work for the stage line. Hynds also opened the popular Capital Saloon a couple blocks from the Hynds Building. The first floor was a saloon with a boxing ring in the back; the second floor was set up for gambling, in which Harry fondly partook; and the third floor was a brothel. A parking garage stands

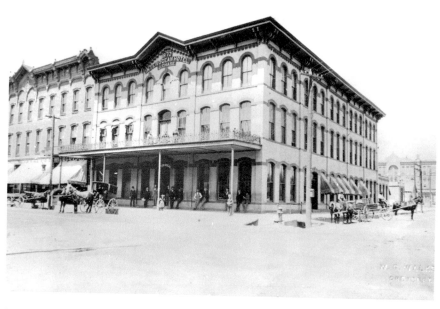

Inter-Ocean Hotel, photo by Walker. *Photo from Wyoming State Archives, Wyoming Department of State Parks and Cultural Resources.*

there today. The community embraced Harry, who was always in the center of the action. He was an athletic, stocky man with a feisty Irish temper and a bigger-than-life personality. The Capitol Saloon was profitable, and Harry also invested in oil and mining, which proved to be lucrative. He graciously gave back to the community, even donating a lodge west of town to the Boy Scouts. Hynds Lodge is still being used by the scouts today. Hynds was so popular that he had forty-two pallbearers, including many dignitaries, at his funeral in 1933.

Over the years, the Hynds Building has housed two different banks. Kathy tells us that the bank tellers' money drawers were often found rearranged in the mornings—nothing taken, just shuffled around, despite all security measures. Kathy toured the vacant Hynds Building, and when she tried to descend the stairs to the basement, she felt a cold, invisible force pushing her back upstairs. Interestingly, this basement was developed as a bomb shelter. Dr. Davis's dentist office was located in the Hynd's Building for many years.

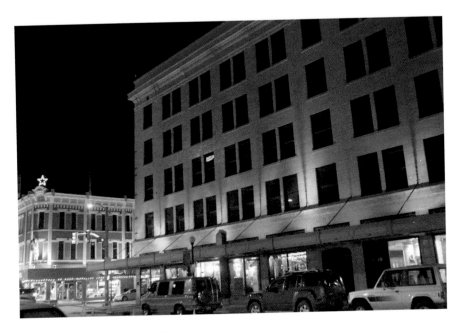

Hynds Building. *Envy Photography.*

Baffled employees would frequently find the dental tools locked inside the elevator, perhaps the sort of pranks child spirits may enjoy.

Rhonda, a young lady in her twenties, relayed the story of her grandparents using an attorney in this building for the adoption procedure of her mother. Each time her grandparents arrived for their appointments, the paperwork would go missing, much to the dismay of the attorney. This happened four consecutive times. Eventually, the transaction was finalized. It's interesting that a family member of her grandfather had died in this very building ten years prior to the adoption. To this day, Rhonda feels ill each time she passes the building.

6. The Atlas Theatre: 211 West Lincolnway

Damsels and Villains

Beside the Wrangler store stands the ornate Atlas Theatre, where you can attend the summer melodrama to cheer the damsel in distress and

boo the villain. The location where a portion of the Atlas Theatre and two neighboring stores stand was the sight of a horrific tragedy when Cheyenne was still a very young city. I don't believe I can retell it as eloquently as the newspaper did, so in the words of the *Daily Leader Newspaper* of September 6, 1879:

> At 9:55 o'clock, when all was calm and still, a thundering crash resounded through the streets of Cheyenne, startling the people far and near, and spreading terror everywhere. The strange sound that seemed to carry horror on its wings, brought consternation to the heart. People filled the streets instantly in a dazed coalition, not knowing whence came the terrifying noise. They ran wildly to and fro until the fire alarm sounded.
>
> There in the light of the pale moon, was seen the ruins of two buildings tumbled about in a confusion that baffles description. Occupied by FE Warren & Gaylord [a music store] and LR Bresnahen [a meat market], above which were boarding houses [sic]. Of course there were human beings mixed up in that awful chaos of bricks, splinters and dirt. Did not the heart-rending cries pierce the air and cut deep like the voice of terror itself.
>
> It was well that the fire companies responded to the alarm, for soon flames arose from the debris. Those precious human lives that were weighted down by the ruins were fast being reached by human aid…the noble firemen were both efficient and courageous, and the flames were quickly subdued.
>
> Then the firemen came upon the body of GFJ Van de Sande, crushed and entirely covered with the dust of plaster and bricks. He talked for some time before his voice hushed forever in stillness in that terrible prison of death.
>
> Others were rescued in quick succession, and by 1 o'clock all were accounted for except two children. The last of the victims was found, at 3 o'clock this morning, when two boys, Gussie and Frankie, six and four years old, were discovered dead. They had been in bed, and were found, arms entwined with each other…Words are powerless to properly speak of the sadness of the scene, or the agony of the frenzied mother. On such an occasion, silence only, is holy.

Fifteen people plummeted down among the rubble. It is particularly devastating that the two youngest perished in such a frightening manner. Their mother was distraught, saying that she had not kissed them goodnight. The buildings were just four years old but had been built with inferior bricks and mortar during a

construction boom. There have been sightings of the apparition of a young boy playing with a red ball on the stairs and on the second floor at the theater. Possibly Frankie and Gussie still play here. Directly behind the Atlas Theatre across the alley is the Wyoming Business Council, where the boy playing with a ball has also been seen. Employees hear the bouncing ball dribbling against the floor.

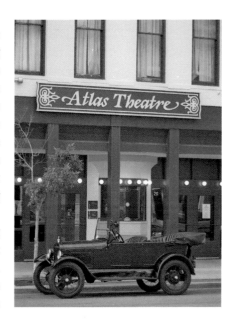

Atlas Theatre. *Matt Idler Photography.*

The Atlas Theatre building was erected on the site eight years after the accident in 1887. A confectionary factory was established in the basement with the treats sold upstairs in a teashop. There were offices in the two upper floors. It was renovated in 1907 into a theater with seating for over five hundred. The lobby had a penny arcade with mirrored panels, including distorting mirrors; automatic fortunetellers; and lung and strength testers. It boasted the most elaborate soda parlor in all the West with nickel fixtures and marble counters. The opening night featured a burlesque act entitled, "The Bell Boy," and a comedy called *Why He Reformed.* Over the years, the theater was used for vaudeville productions, as well as silent and talking movies. In 1930, the Strand Theatre replaced the Atlas downstairs, with the Strand Hotel occupying the upper levels. You can still make out the faded ghost signs for the Strand on the east side of the building. In the 1960s, it was the Pink Pony Night Club and later became the Cheyenne Old Fashioned Melodrama owned by Cheyenne Little Theatre. The theater has changed very little over the past century; it is lovely but in need of some restoration work. This building has housed many people and businesses over the years, leaving numerous physical and spiritual fragments of days gone by lingering within its decorative walls. It is believed that there are at least seven spirits in the Atlas building.

Two young lads accompanied their fathers to the Atlas Theatre some thirty years ago. The men were there working on a charity auction. Meanwhile, the boys were playing on the stage, running back and forth. They stopped dead in their tracks when they saw a man and a woman up above in the

projection room. The boys found it odd that these people were in formal clothing, the lady in a floor-length gown. They ran into the lobby, where they located their fathers. Catching their breath, they excitedly spewed out questions about the couple. Their fathers said there was no one else in the building, just the four of them. Of course, the men checked the projection room but found no one.

The theater actors refer to one of their ghosts as the "blue girl." You can smell flowers when she is around. On the second floor, Henry was standing alone when he thought a fellow employee walked up beside him. He could feel a presence and turned to speak, but there was no one around, just a sweet fragrance.

There's a story that's been passed along over time. Two actors melded into the characters they played, only to exist in their roles for all eternity. It was on the second floor where an actor who portrayed the villain was overcome with jealousy. He spun into a horrific rage, taking aim at his betrothed, the heroine, and the exquisite actress took a bullet through the heart from the

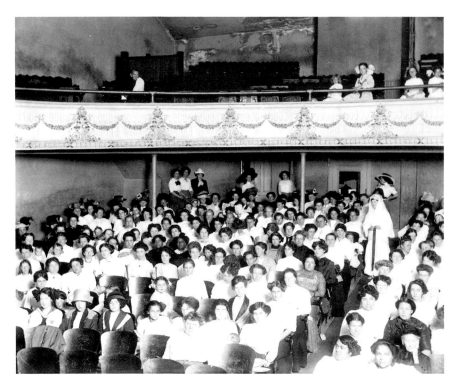

Atlas Theatre audience. *Photo from Wyoming State Archives, Wyoming Department of State Parks and Cultural Resources.*

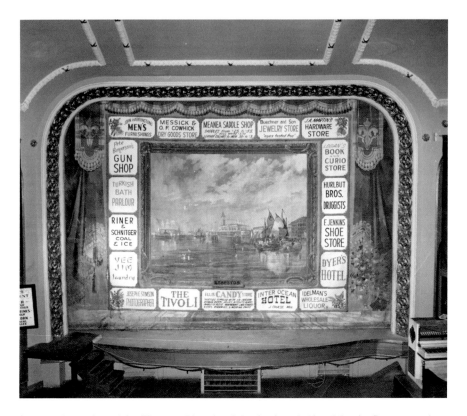

Stage and curtain at Atlas Theatre. *Photo from Wyoming State Archives, Wyoming Department of State Parks and Cultural Resources.*

man she loved. He was later found on stage, dangling from a noose tied of the curtain ropes. There are visions of a lovely woman in a flowing white gown seen throughout the theater. She has been mistaken for a live person at first glance. The villain is also seen in a top hat and cape, lurking in the shadows backstage.

PHOG worked with the Atlas Theater for the 2012 Zombie Fest, a macabre Cheyenne event certain to entertain. The team did some paranormal investigations at the Atlas and experienced some extraordinary things. They captured an electronic voice phenomenon (EVP) of a bloodcurdling scream on the second floor. During the investigation, they asked out loud, "If you are here, please knock," which was followed by distinct knocking sounds. PHOG brought in a spirit box to see what they could get. This is a device used to communicate with spirits. They asked the spirit its name, and the response was "Mitchell." They actually heard the name Mitchell

three times during the session. A couple times, the voice said, "Jose," which is the name of one of the team members; they also captured the words on two different video cameras with audio. When Arla asked, "Is this where you live?" the answer was, "It's work." The lights are off during these kinds of investigations, and PHOG has infrared cameras that work in the dark. When one of the cameras snapped a picture, the flash went off and through the spirit box they heard, "F#@% that!" Then they heard "Who is that, Tom?" The responses came very quickly when they asked questions. They said, "Where are you standing right now?" and through the box came the word, "hallway." Jose was wearing a sweatshirt with a PHOG logo on it. When Jose said, "Can you spell out the letters on my hoodie?" they heard "P...H...O...G." The group was quite perplexed with this interrogation by this point. Suddenly feeling extremely drained, Jose slipped out of room. He was silently praying in Latin. They all heard a voice from the spirit box say, "Amen" as he concluded his prayer. When watching the video, a large orb flew from Jose's back at this time. PHOG was able to pull the veil back for a few moments, connecting with this other world.

Another ghostly encounter happened to Claire, an actress, as she was trying on a formal gown for a dinner party scene. The lights went off in the restroom. Enveloped in darkness, she tried to calm herself. Claire thought the power must have gone out in the whole theater. She took a deep breath, extended her arms and patted around until she felt the solid wall. She slid her hands around trying to feel the doorknob. Finding the knob, she encircled it with her hand, turning and pulling as hard she could, but the door didn't budge. She could not get out of the bathroom. Eventually, the door simply opened. She quickly ran down the aisle to see if everyone was OK, but they all looked at her with blank expressions. No one knew what she was talking about, as the lights had remained on in the rest of the theater. She was the only one who had experienced the darkness. Her fellow thespians assured her that they had not messed with her; no one had left the stage.

During another production, Claire was doing a scene where she was inside a chest. She had to remain still inside the chest until her finale when she jumped out. She heard everyone talking around her right outside the chest. Claire had been inside the chest for much longer than planned, and she gently pushed against the chest, but it didn't move. She knocked a couple times to catch their attention, but there was no response. She knocked again. Hot and stiff, she couldn't take it anymore, Claire heaved the chest open. No one was there, but the voices were still there. The cast was clear out in lobby; they had forgotten she was in the chest. Out of sight, out of mind.

7. DEC'OROOM AND ERNIE NOVEMBER STORE: 215 AND 217 WEST LINCOLNWAY

Revenge Served Cold

Directly west of the theater is the DEC'ORoom Lighting store. The two buildings that collapsed also included the space where DEC'ORoom and Ernie November are now. The 1895 city directory lists George Hoyt as a druggist at this address. Hoyt was in the Wyoming State Senate from 1893 to 1897. He was named postmaster, so he sold his store. An advertisement from September 5, 1897, shows that the Western Union Office was here. The current building went up in 1900, and it is a two-story brown brick, remodeled in 1951. The 1902 City Directory lists Truckey & Son, and a 1923 CFD Souvenir Program has an ad for the Demis Café at this location. Later, this building and the one beside it were Peoples Sporting Goods, where I personally purchased my first snow skis in 1980.

When the owner of DEC'ORoom lighting store comes into work, she sometimes finds lamps have been intentionally moved. Some of them were hanging on the walls, but she finds them placed on the floor out in the center of the walkways. If they had fallen off the walls, they would be laying broken beneath where they were hanging. Instead, they are found a significant distance from the wall in places where they could not have rolled because there are displays to block the path. She does not have any employees, but it seems she does have a helper.

Ernie November Store is in the next building on the block, heading west. In 1909, Palmers Bakery was located here. The Lyric Theater was at this location, extending farther west than this store, from the late 1920s to the mid-1940s. I was told it was a pawnshop for a short time, and later it was part of Peoples Sporting Goods. Today this is a fun store where you can still purchase record albums. If you want incense and black lights, this is the place for you.

At Ernie November Store, Keith watches intently as a door opens by itself every now and then. The employees have determined that the wind gypsies could not be responsible for this. Working upstairs, he is sometimes jolted from his thoughts when he hears the slamming of a door in the basement below him. No one is down there. Keith says the doors slam so hard that you can feel the shake. Jose of PHOG took some photos of Keith in the basement, and there were numerous orbs surrounding him. Oftentimes orbs

Lincolnway (Sixteenth Street) DEC'ORoom and Ernie November Store. *Jill Pope.*

can be caused from dust reflections, but the sheer number of orbs seemed excessive for that.

A woman stopped into the Visit Cheyenne office one afternoon and discussed the downtown history with us. This is the story she told. Her husband's great-grandfather owned the Guernsey Hotel, one hundred miles north of Cheyenne. When he went off to war, his wife sold everything he owned without his permission and moved to Cheyenne. Upon his return from the war, he drove to Cheyenne. Full of emotion, he met his estranged wife and her daughter at the Palmer Café, which was located on the site of the current office, and angrily he asked for a divorce. When she said yes, he took his revenge by shooting her daughter. The woman said there were one hundred witnesses who watched the young woman's life slip away. He was sent away for life but was pardoned after ten years. He died in 1928.

8. Wyoming Home: 210–212 West Lincolnway

George Is on My Mind

It was a beautiful autumn day in 2007, and we were putting together the trolley script for the upcoming ghost tours. Trolley driver and historian

Valerie Martin and I decided to hit the streets and interview some local business employees. One of the stops we made was at a local treasure, the upscale Wyoming Home Store, which specializes in western décor, furniture and fine art. The store is across the street from the Atlas Theatre. We already had some paranormal experiences documented at Wyoming Home but thought we would ask if there was anything new. The two sales clerks looked shocked when we inquired; it seems there had been an occurrence that very day. The ladies were both standing near the checkout counter at the front of the store chatting while unpacking new merchandise. Out of the blue, they witnessed a heavy glass shelf soar straight forward with significant force on its own accord. Defying gravity, it levitated for a moment before crashing to the floor. The glass shattered into thousands of pieces. The ladies were frozen in their spots for a few moments trying to register what they had just seen. They were quite shaken but not completely surprised. The resident ghost occasionally lets his presence be known.

The Wyoming Home Store was forced to relocate into the space next door after a fire took out a portion of the block in 2004. The owners forged ahead and renovated what was left of the store, and then spread to the west in the neighboring commercial space, taking great care to keep its beautiful original architectural style. The east portion of their store was originally the First National Bank, built in 1882. The bank was on the main floor and a section of the second floor. The esteemed Francis Warren occupied the third floor. Various businesses were here over the years, including Adamsky Optometry and Jenkins Shoes. The west side of the store was originally the Commercial Building. The bank building and the neighboring commercial building were connected on each floor so one could travel between buildings without exiting. The commercial building contained the U.S. marshal's offices, which remained there until 1906. Other former tenants include the U.S. District Court and the Signal Corporation, which was a forerunner to the weather bureau. The ground level was occupied by Henry Altman & Company, a wholesale wine, liquor and cigar dealer, and JS Collins & Company, famous saddle and harness makers. Western Ranchman Outfitters successfully operated in these buildings for half a century.

Originally there were no fences in the west; once branded, cattle was turned out by the ranchers to graze in wide-open spaces. Cattle theft became a big problem, so the Stock Grower's Association was created. They held round-ups and hired secret cattle detectives to check the brands and catch the thieves. The first roundup was held in 1874. A top ranch hand, stagecoach driver and rodeo rider named Tom Horn was hired as a cattle

Left: Cheyenne Street Railway Trolley at Wyoming Home Store. *Matt Idler Photography.*

Below: Commercial Block, built in 1875. *Matt Idler Photography.*

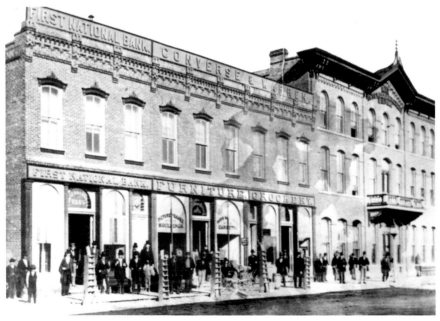

detective. He had lived with Indians for a while and had fine-tuned his scouting skills with their guidance. He was personally asked by Geronimo to be his interpreter when he surrendered to the U.S. Cavalry the fourth and last time. Unfortunately, Horn became callous and later used his skills as a hired assassin. Tom Horn is the subject of one of Cheyenne's most infamous legends when he was hanged for murdering fourteen-year-old Willie Nickell. Most of the locals felt that the bullet was meant for Willie's father. You see, Willie was wearing his father's hat and coat and standing beside his father's horse at the time of his slaying. Horn's signature was to place a small rock under his victims' heads, and since a rock had been found under the teenager's head, it was assumed that Horn was the shooter. He was captured at the Inter-Ocean Hotel. His interrogation was held at U.S. Deputy Marshall Joe LeFors's office, on the second floor of the commercial building, which is Wyoming Home today. Horn was investigating cattle rustlers at the time of the boy's slaying, and he had information that would point the finger at powerful cattlemen in a number of murders. Plying Horn with alcohol, Marshall LeFors got Horn to confess. He arrested Horn right then and there. Once sober, Horn professed his innocence, but it fell on deaf ears. Horn was penniless, but influential friends spent $100,000 for his defense. The general public had convicted Horn before the trial ever took place in October 1902. It is said that Horn was out of town when the murder occurred, and the bullet was a different caliber than the gun Horn typically used. Despite his expensive defense, he was sentenced to death by gallows, becoming the last man to be legally hanged in Wyoming. Engraved invitations were mailed out to attend his hanging in November 1903 before many spectators—quite the social event of the day. Horns' conviction silenced him forever. His guilt remains controversial to this day; most people believe Horn was framed. About ten years later, ranchers began putting up fences along with branding their stock, and this proved more effective against cattle rustlers. The Stock Growers Association still exists today and works to promote the cattle industry.

The upper floors of the commercial block, now the Wyoming Home Store, have been beautifully restored as offices. The U.S. marshal's office where Horn was interrogated is now a conference room. In 2007, the owner let a paranormal investigation team come in. The investigators said they definitely believed there was a spirit present on the second floor. In 2006, one of the rugged construction workers hightailed it out of the building from the second floor and would not return. He had been thoroughly spooked. A secretary at the American City Defenders on the third floor often sees

Shopping at Wyoming Home. *Matt Idler Photography.*

a man who tips his cowboy hat in a gentlemanly fashion and walks on. While he is visible, he displays a transparent quality.

In 2005, store employees spoke of a prankster spirit making regular appearances whom they affectionately called George. While many of them experienced his exchanges, there was no reason for alarm. He took a liking to one particular worker named Jessica. She felt him around her often. She swears he followed her from work one day and was in her car with her and then at her next destination. Jessica felt he was protective of her, so she wasn't concerned. John worked with Jessica, and he told her that he often felt like someone was there but could see no one. Then he felt someone breathing on the back of his neck, it unnerved him. George's attachment to Jessica seemed to escalate. During one shift, John and Jessica were working side by side in the storeroom. George became jealous, possibly enraged by his own restrictions to interact with Jessica in the physical world. George accosted John, maniacally lifting him completely up off the floor by his throat, leaving John's feet dangling against the wall. John couldn't breathe, his heart was pounding through his chest and he was panic-stricken, not knowing how to fight off something he could not see. Jessica watched in horror, and despairingly, she ordered George to release John immediately; fortunately, George ceased his vile act.

The name "George" for this ghost may not have been chosen entirely at random. One the fateful day of Friday, November 13, 1891, the Cheyenne National Bank closed up—lock, stock and barrel—it was deemed insolvent. George Beard had been the manager of the bank for ten years. When the bank was forced to close, George felt like a failure and took the full responsibility upon himself. George lived across the street from the bank in a second-floor apartment at Ferguson (now Carey) Avenue and Seventeenth Street. Humiliated beyond reason and driven by despair, he went home and shot himself in the head. He was just thirty years old. Shortly thereafter, John

Collins, the bank's founder, was arrested for embezzlement, which was the true reason the bank had failed. George had died in vain. John Collins had moved to California and started another bank before his theft was exposed. When he was found out, he also shot and killed himself.

The building directly behind the Wyoming Home is also active with spirit activity. This is the area where George Beard lived and died. The people working in the Seventeenth Street store had also named their ghost George, without being aware of the George at Wyoming Home, possibly one and the same. Some say there is no such thing as coincidence. Since George lived and worked on this block in the physical world, he may have chosen to stay in familiar surroundings.

Over twenty years ago, Jerry was preparing to open an art gallery at this Seventeenth Street location. He was doing all the mundane things that must be done such as cleaning, rearranging and painting. He had just installed his business phones and a new security system. Exhausted, he left for the evening. It was nearly midnight when he got home, and unable to unwind, he called the business line to check if the phone system was working. He got a busy signal, which shouldn't have happened because he had set up

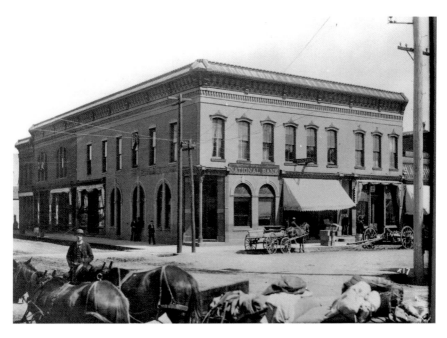

Cheyenne National Bank, where George Beard worked. *Photo from Wyoming State Archives, Wyoming Department of State Parks and Cultural Resources.*

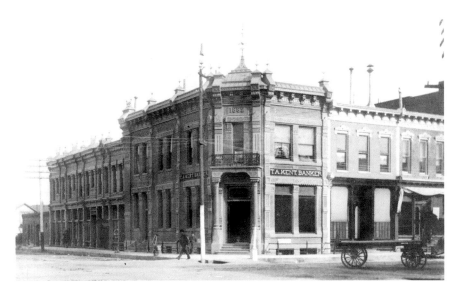

Corner of Seventeenth Street and Ferguson (now Carey Avenue) where George Beard lived. *Photo from Wyoming State Archives, Wyoming Department of State Parks and Cultural Resources.*

voicemail. Jerry figured that he'd done something wrong, and antsy, he went back down to the store. The security system was activated, so he disarmed it and grudgingly climbed the stairs up to his office. Stepping into the room, he became frightened because the phone had been taken off the hook, and the cord was wrapped around his chair back with the receiver lying in the seat. Now the interesting thing is that the ghost at the Wyoming Home store had also taken the phone off the receiver and wrapped it around a chair. The ghost seems to be saying, "Don't call us, we'll call you!"

Strange things continued to happen over the years that Jerry had his gallery here. He nicknamed the ghost George, not knowing anything about the George at Wyoming Home. Jerry had been out of town for a few days, and when he returned, his employees didn't believe that he had truly been gone because when they came in one morning all the furniture upstairs had been stacked up ceiling high against the doorway, but the alarm had not gone off.

The second-floor rooms are old offices and remain much the same from the many days that Flory Shoes operated here. The third floor had been boarding rooms with a pleasant common dayroom with a fireplace in the center and vintage fabric wallpapers and tile flooring. A tenant told us that the owner had been at the building sorting through his things. He threw away some items from the third floor that had been stored up there for years,

taking the articles down to the dumpster in the alley. The next day, the items were discovered back in their original spots on the third floor. The owner shared some historical information, saying that the esteemed Bresnahan family has ties to this building. Lawrence Bresnahan was elected mayor of Cheyenne for five separate terms. His son had his office in this building for many years, retiring in the late 1950s. At that time, he gave the owners his oak roll-top desk in a gesture of kindness. The treasured desk remains in the building today. In the early 1960s, building owner Bob St. Claire tore down the west part of the building and built what is now the downtown mall to accommodate Woolworths. The city directory tells us that the Model Market was at this site in 1902.

I met David, a photographer who was a tenant in this building in 2009. Curious if George was still acting out, I asked if he had any ghost activity at his store. I caught him off guard; he'd had a few very strange things happen recently and was a bit freaked out by it. After meeting a homeless man, David and his kind-hearted wife bought him dinner and gave him work painting the studio. They went so far as to allow him to sleep in the upper level. Grateful to have a place out of the weather, the fellow said he didn't mind being locked in from the outside. When David returned the next morning, he found the large front display windows had been smashed out, and the man was gone. Disheartened and feeling a bit taken, David called the police. They found the bum, who said he didn't want to destroy anything, but he had to get out. He was terrified, saying the place was really haunted! Not knowing the man's mental stability, the police and David just shrugged it off. Soon after this, David was working alone in the locked building. He distinctly heard footsteps above him. David grabbed a nearby metal pipe and walked through the building but found no one. As soon as he began working again, the footsteps resumed. Again he grasped the pipe and strode through the building, his adrenaline pumping and goose bumps rising, but once more, he found nothing.

The next day, David was working in the back room when he heard the front door chimes ring. He went out front to assist the customer, but no one was there. Returning to his task, the bells rang again. The third time it happened, David swore out loud, frustrated, and he said, "Quit it!" The activity ceased.

IV.
LINCOLNWAY, WEST 300 BLOCK

9. FREEDOMS EDGE TAP HOUSE/TIVOLI BUILDING: 301 WEST LINCOLNWAY

Block Party

When Cheyenne sprung up in 1867, most establishments were set up in tents. The first business in a wooden building was a saloon put up here at the corner of Lincolnway and Ferguson (now Carey) Street. Four years later, things had been built up substantially, but then the entire block was lost in the 1870 Great Disaster Fire. The fire began at the opposite end of this block in a faulty flue at T.A. Kent's liquor store. Once the flame ignited, the strong winds took hold.

This block contains boundless history of Cheyenne, retaining some part of those who dwelled here and coloring the present. The history books are brimming with material, as the block was packed with saloons and variety theaters and was a hub of activity. The McDaniel's Theatre was one of the most acclaimed theaters in America, located at the northeast corner of Lincolnway and Eddy (now Pioneer Avenue). At eight o'clock in the evening, a band would assemble in the street blaring music to gather and entice crowds to move inside of the combined saloon, theater and museum. James McDaniel was quite the enterprising showman. There were monkeys, anaconda snakes and even a grizzly bear inside the prosperous business. The

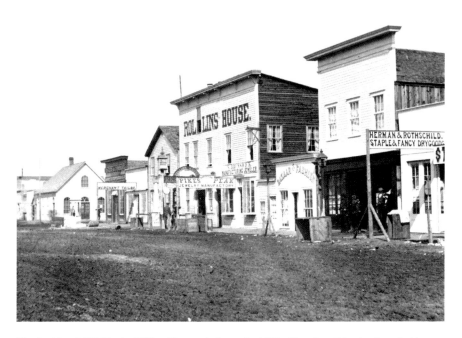

North side of 300 block of West Sixteenth Street in 1869. *Photo from Wyoming State Archives, Wyoming Department of State Parks and Cultural Resources.*

theater had billings of a mermaid, a seven-foot-tall giantess from England who weighed four hundred pounds and an American dwarf, weighing fifty pounds. It also featured opera and Shakespeare productions. Today the north side of this block is a parking garage. The south side of the street includes the following shops from which I've been told of ghost encounters: Freedoms Edge Tap House, Epitome Cosmetic Boutique, the Quilted Corner, Carnival Antiques, Graffito Paint Your Own Pottery and Our Place.

Ghosts on Tap

The Tivoli is a lavish Victorian building on Lincolnway, Cheyenne's main street. Visitors certainly notice the Tivoli's elaborate architecture when they come into town. It originally opened in 1893 as a fine restaurant and saloon. It had a beer garden and, as was usual at the time, a brothel upstairs. Ladies were allowed to come for tea at four in the afternoon, while being serenaded

by organ music. It is rumored that men could pass through tunnels under the streets to the Tivoli and other businesses. If they were visiting the upper floors, they could enter discretely. When the discussion of a new city event, Frontier Days, came up, the planning meetings were held at the Tivoli. At this writing, we are now entering our 117th Cheyenne Frontier Days celebration; it has gone from a two-day rodeo to a huge ten-day festival, being the largest outdoor rodeo in the world. During Prohibition, which began in 1919, the Tivoli was a posh speakeasy and brothel. Twelve years later, prohibition ended, and the bar was reestablished and ran until 1965. The age of the Old West saloons was never really the same after Prohibition. The Cheyenne Chamber of Commerce offices operated here for several years. Our current Wyoming governor, Matt Mead, used the building as his campaign headquarters. Today it is Freedoms Edge Tap House. Stepping inside is a delight to the senses. This building had been renovated to its original glory. The massive mahogany wall and counter are exquisite.

Late one evening, a couple employees of the chamber of commerce were still working in their office at the Tivoli. Melody was deep in thought,

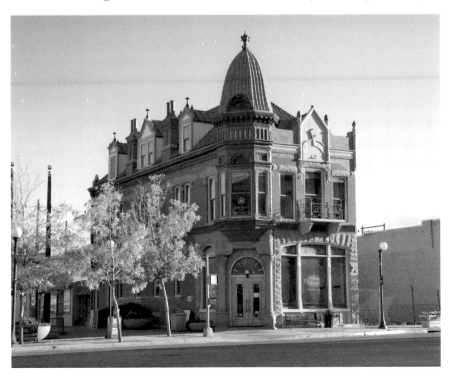

Tivoli Building/Freedom's Edge Tap House. *Matt Idler Photography.*

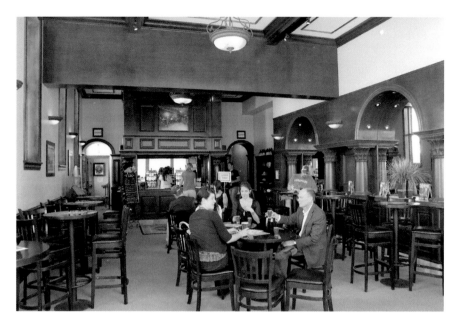

Inside Freedom's Edge Tap House. *Jill Pope.*

concentrating on her project at hand as she began to climb the stairs, when out of the corner of her eye, she saw a woman. Assuming it was her co-worker, she began to speak, but when she looked up, she was startled to see the apparition of a woman in a long, flowing gown standing at the top of the staircase with her hands placed on the railings. Melody was frozen in place, and she began trembling. Once she had gathered herself enough to move, she fled back to her workstation, grabbed her purse and quickly ran out of the building. Melody never worked in the building after dark again.

The Tivoli housed a quaint coffee shop for a couple years. One of the employees spoke of watching a female spirit move a coffeepot and then slide cups completely off the edge of the counter. They went crashing to the floor as the stunned employee stood there with her mouth gaping open.

The old, decrepit elevator in the Tivoli building was disconnected some years ago, but one of the coffee shop employees said that every day, she heard the sound of the elevator slowly creaking up and then going down, all on its own, at 6:27 a.m. I'm not yet certain which of the many ghosts that reside here is responsible for the elevator movement. There is an account of a man jumping from the second-story balcony and snapping his neck, so possibly he prefers the elevator now!

Elderly citizens of Cheyenne remember the 1930s, when the girls at the Tivoli could be seen leaning out of the upper-story windows, calling out to all the fellows to come on up. One elderly woman who has lived in Cheyenne her whole life recalled the story of a lady of the evening who was hanged from a wagon wheel–style light on the main floor. The victim was going to announce that she had been cavorting with a high-profile gentleman in the community and was pregnant with his child. She had been murdered to keep her silent. But this deed did not silence her completely; she is now heard wailing through the sound system when it is turned off. The wagon-wheel lights on the main floor would often swing back and forth of their own accord and flicker on and off before they were removed in a renovation.

During some of the construction over the past decade, the carpenters heard male and female voices coming out of thin air. Their tools and various objects would move, and doors would slam with relative frequency, all unaided by any person…that they could see. They couldn't wait to wrap up the job.

The current Tap House owners have not had any paranormal experiences, but they've had customers who have. Some customers have mentioned seeing a lady in the upstairs windows, but no one is up there, just imprints of soiled

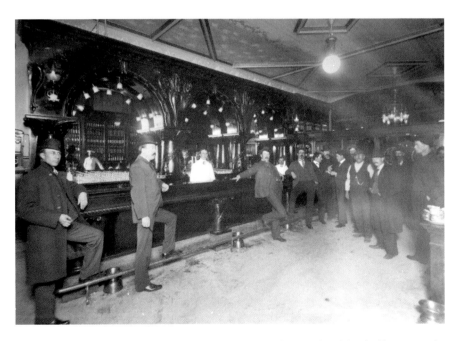

Inside the Tivoli saloon in its heyday. *Photo from Wyoming State Archives, Wyoming Department of State Parks and Cultural Resources.*

doves. They allowed a paranormal team from Casper to come in. The team used a Maglight flashlight and asked the spirits to blink the light once for yes and twice for no, from which they got appropriate responses.

The manager at Epitome cosmetic boutique has always been very intuitive, and she says there are definitely spirits within the store, but none reside there. She feels traces of spirits, as though the store is a passageway for many spirits walking through, going to and fro. This block was one of the most active in Cheyenne's early years. The store is located at 307 West Lincolnway, next to the Tivoli, so many patrons from years ago may be coming and going on another plane walking among the living.

10. QUILTED CORNER: 309 WEST LINCOLNWAY

Fabric of Their Lives

A decade ago, this was the location of Visit Cheyenne, which is my employer, before we moved into the renovated depot in 2004. I did not personally have any paranormal experiences while I worked here, but other staff members did. The current owner has been here since 2004 and has not experienced anything she would call paranormal, and she thinks it is nonsense. I always thought it was fun that our office was once the location of both the Pioneer Saloon & Restaurant and the Elkhorn Saloon. We know the Bernina Sewing Machine Store was once here.

There are a couple articles in the *Wyoming Tribune* from January 1896 that speak of Daisy Shaw, who made her way to Cheyenne after her husband abandoned her. With few career options for women in that era, she ended up working at the "333," a house of ill repute at the west end. The news articles report that a customer of Daisy's who was a soldier at Fort D.A. Russell stole the few valuables Daisy had: her money and jewelry. It seems Daisy had feelings for him and was devastated by his actions. Not able to cope with any further betrayals or bad fortune, Daisy swallowed a large quantity of morphine. She was just twenty-three. The other women of the house pooled their money and paid for a funeral and burial. There is a photo of the Tivoli building taken during a Cheyenne Frontier Days Parade around 1900. The photo shows the east half of the block. In the center of the block, approximately where the Quilted Corner and Epitome are today the

building displayed a 333 sign painted on the outside of the brick building. It's where Daisy took her last breath.

Our first Cheyenne Street Railway Ghost Tour was held in 1994 while the Visit Cheyenne office was located on this block. The staff was excitedly preparing for the maiden voyage. The office was closed, and Jodie was the only person there. She was sitting at her desk smoking a cigarette, something that wouldn't be allowed today. She had quit smoking but had recently fallen back into her old habit. The tour was to begin at the Gunslingers Sody Saloon, half a block away. Jodie locked the doors and then walked over there to perform her duties as ticket taker. After all the riders had boarded the trolley, and the tour began, she went back to the office. She entered the empty space, approached her desk and was shocked to see that her ashtray was empty and clean. Jodie often saw an apparition of a man wearing wingtip shoes lurking in the shadows. She could feel him watching her while she worked.

Another employee said she would often feel an icy presence surround her. Every night, an employee would tightly latch the gate at the top of the steps that led to the unfinished, dirt-walled basement. None of the staff liked going down there. The following morning, the gate would always be unlatched.

Doing tourism business as usual at Visit Cheyenne, a psychic happened into the Visitor Center one day. At her request, employees let her explore the dingy basement. She came back up and said that the spirit really wanted them to call him by his correct name of "Clarence." Since Clarence appears in wingtip shoes, it's possible he was a victim of the 1934 explosion. The two men from the Mecca Rooming House were never located, as explained in the following section.

Explosion: Hot Flash

It was nearly midnight on the moonlit evening of June 27, 1934, when there was a thunderous explosion on this block. The blast took three buildings and at least three lives. Many others were miraculously spared, and people were seen fighting their way out of the debris and flames, bruised and battered but alive. Bystanders were knocked off their feet, and several young men across the street were dodging the flying red bricks. The newspaper said some tourists fled town, believing it was a bomb. The *Wyoming State Tribune* reported that the echo was heard two thousand miles away. The blast came

from the location of the United Grocery, which stood in the middle of the block between Sol Bernstein's Clothing Store and Bon Tons Restaurant, both of which had rooming houses upstairs. The explosion had all the characteristics of a gas leak because it created a vacuum within a closed area at the instant of explosion, but authorities could not find the leak. There was an exhaustive inquest. The lives snuffed out from this mass hysteria were Doris Reed, Yvonne Signor and Margaret Mitchell, who was the proprietor of the Mecca Rooming House. The doctor was on his way to treat Mrs. Mitchell for a heart attack when the explosion occurred. Her number was up, one way or another. One or all of these women may still reside on this block, as there are several accounts of female sprits. Two men were supposed to have been in the upper floor of the Mecca boardinghouses, but their bodies were never recovered. They most likely met their doom The men's names were not given in the newspaper. The question is whether either of them was named Clarence.

11. Lavender Boutique: 315 West Lincolnway

Voice from the Other Side

Continuing west on the block, in 1888 the Board of Trade Exchange was located at 315 West Lincolnway, and it sold fine cigars, wines and liquors. The Royal Hotel was here around the turn of the century. The 1902 Capitol City Cigar Factory and Pool Room was here, according to the city directory. The sketchy Earls Bar was located here in the late 1920s. People referred to it as "Bucket of Blood" because it was so rough. A well-known local rancher told our trolley driver Rick Ammon that he and the ranch hands would frequent the bar. He recalls that there were brawls there all the time, saying they had to renovate every two weeks.

Lavender was a wonderful boutique located here for a few years, closing in 2012. When you entered the store, delightful fragrances enveloped you, but occasionally people would also smell an unsupported burning odor here. Concerned, Wendy, the storeowner, contacted her landlord, but try as they may, they could not pinpoint a source. The smoke aroma is a pattern on this block.

One night after closing the boutique, Wendy went into the basement to prepare a package for mailing. She turned the lights on in the side where

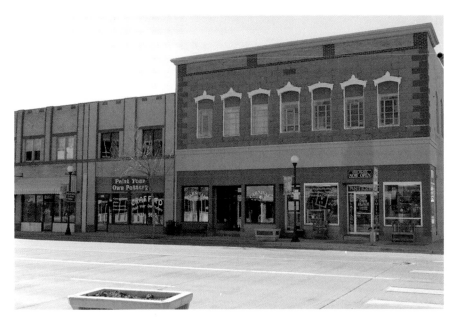

The 300 block of West Lincolnway (Sixteenth Street) in 2013, showing Our Place, Carnival Antiques and Graffito. *Jill Pope.*

she was working, but it remained dark on other side. Through the blackness, she heard a woman's voice call out to her, "Hello." Although it sounded as though the trailing voice was coming from the other side of the basement, Wendy figured it must have come from upstairs even though she was sure she had locked the doors. Wendy sprinted upstairs, but no one was there. Unnerved, she tentatively returned to the basement, but before long, she heard the voice summoning her from the darkness. Adrenaline pumped through her veins as she darted up the stairs and swiftly left the store. Wendy said her husband, who is a tough ranch hand, has never liked the basement, stating that he got a negative vibe down there. She avoided the basement as much as possible after that and only went down there in the daytime. Oftentimes she felt there was a presence around her in the boutique. She turned up the radio volume to distract herself from the spirits that inhabited her store. Wendy's husband accepted a job on a ranch in another town, so she moved, and unfortunately the store closed. A new business appears to be setting up shop at the time of this writing.

Some of the addresses from more than one hundred years ago cross over today's address property lines, with the building boundaries varying over time. Therefore an address listed in the 1880s directories or advertisements

may actually be located in the neighboring building from that time with the same address today, or it might have been positioned so that it was located in portions of two of today's structures. Consequently, some of these adjoining stores share ghosts.

When visiting the three businesses on the far west end of the block, I discovered they are connected, all part of one building. This happens to be the oldest commercial building still being used in Cheyenne today. In the back receiving area of the stores, there is a common area with a large open space to all three of the stores. The owners amicably share the large room and the spirits that reside there. The employees of these three adjoining stores have seen an apparition of a Victorian-clothed woman in the back room. The upstairs tenant has also reported seeing the female apparition. After the Great Disaster fire, Addom's & Glover built this two-story brick building on the corner for its drugstore. Today it is the location of Our Place, which sells vintage collectibles; Carnival Antiques; and Graffito Paint Your Own Pottery.

12. Graffito: 317 West Lincolnway

A Woman at the Bottom of It

At Graffito Paint Your Own Pottery, you can select pottery items, paint and fire them, taking home your own work of art. This is part of the Addom's & Glover Drug Store, the oldest business building still being used in Cheyenne. When you are inside of Graffito, the east interior wall is brick and was once the exterior wall; you can still see where they bricked in the windows that were part of the wall facing the alley, making it the corner building. April, the owner, has seen a photo that showed girls hanging out of the windows. The wall is a great piece of history preserved. April said that they hear the sounds of women's voices coming from upstairs. This space was a rooming house and brothel. The remaining rooms are still divided into little apartment areas with small sinks.

Barney Ford came to Cheyenne in 1867 and established the Ford House, a hotel and restaurant that was located where Graffito is today. Barney escaped slavery through the Underground Railroad and made quite a name for himself. Despite the prejudices of the time, he owned and operated many successful businesses in his life. The Ford House was the most popular

restaurant in town. A meal cost one dollar, and the restaurant served over two hundred customers for each meal. During the bustling lunch-hour rush in March 1868, a couple men exchanged heated words over a woman they both desired. The man named H.W. Dodge was standing in the aisle between the tables, and he suggested they go outside to discuss the matter. His adversary D. Burtis declared, "We can settle it right here." In a gesture of goodwill, Dodge placed his hand on Burtis's shoulder. At that instant, a shot rang out through the restaurant, with Burtis possessing the shooting iron. The unarmed Dodge crumpled to the floor, lifeless with a bullet in his spine. The *Cheyenne Leader Newspaper* headlines read, "A Woman at the Bottom of It." The Ford House burned in the Great Disaster fire the next year. Two blocks of businesses were destroyed, with seventy properties gone. Barney rebuilt in the same location a couple months later.

The day before the shooting in the restaurant, two lynched bodies were found at the east end of Linconway. The victims were Charlie Martin and Charles Morgan—not a good day to be a Charlie! Morgan was accused of being a mule thief. Martin had shot Andy Harris in Harris's own business located on West Sixteenth Street. Martin was acquitted at his trial, but the vigilantes found him guilty in their unmerciful avenging secret court. Harris

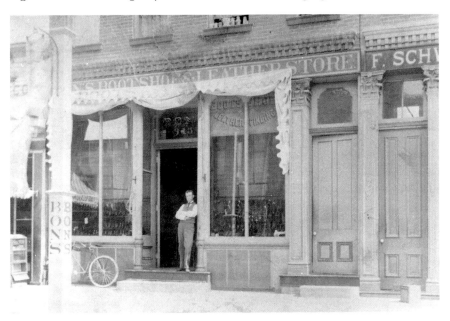

Mr. Bon is leaning in the doorway of his shoe store. *Photo from Wyoming State Archives, Wyoming Department of State Parks and Cultural Resources.*

is yet another being who may be hanging around this block after his life abruptly ended.

To give you further history of what has been on this block over the years, in 1872 when Cheyenne was five years old, a two-story brick was ran by Fred Schweickert, where Graffito is now. A hardware store operated here for decades, having three different proprietors. The hardware store adjoined to Stephan Bon Boot & Shoe Store. In 1902, the Capitol City Cigar Factory and Capitol City Pool room was listed here in the city directory. In 1934, the United Grocery, where the explosion occurred, was in this proximity. It was sandwiched between Sol Bernstein's Clothing Store and Bon Ton's Restaurant, both of which had rooming houses upstairs. One of these was the Mecca. The building was razed in 1990 because it was deteriorating. A new two-story building was constructed in its place. Frontier Printing took up half the west half of the block for nearly forty years.

13. Carnival Antiques: 319 West Lincolnway

Peek Into the Past: Celestial Carnival

I've known Linda, the owner of Carnival Antiques, for many years. When she relocated her marvelous antique store downtown to this block, I went in to see her wares. Linda had already faced the past here. At the time, she questioned whether the experiences in her new location come from the energy living within the walls or if they came with the antiques she displays. Linda was raised in New Orleans and admits to being superstitious; paranormal activity frightens her.

During her first week here, she was setting up shop when she smelled a strong burning odor. Bewildered, she walked through the entire store, and soon the heavy smell dissipated. The building has all new electrical wiring, so it was particularly strange. Customers sometimes express concern because they too smell smoke. The fumes manifest often enough to make her apprehensive. Awkwardly, Linda questioned other proprietors on the block and discovered they were also experiencing the smoke fumes, possibly residue of the Great Disaster fire and the explosion.

One afternoon, Linda was delighted to discover a lovely woman in a wonderful Victorian costume standing among all the collectibles of the same era. She gleefully greeted the woman and called out to her employee to

Inside the fanciful Carnival Antiques. *Jill Pope.*

come see this lady's fabulous outfit. At that very moment in time, the woman vanished before her. Linda was floored. The woman had been so vivid that she had not questioned that she was not alive and breathing. Linda was given a peek into the past when the woman materialized in familiar surroundings.

Another day Linda was standing behind the counter looking downward at papers when she noticed a man in a long frock coat just a few feet from the counter. She looked up, giving him her full attention. There was no denying what he was, because she could see right through him. He consisted of gray particles, but he was opaque enough to discern what he was wearing and to think he was human at first glance.

Some of the businesses located here over the years include the Captains Café in the 1870s and 1880s, L.E. Stone; Richardson Bros., which owned the Tivoli as well; J.L. Murray's business, who was mayor from 1901 to 1903; Hofman Bros., which had a saloon on Fifteenth Street in the 1870s; Cheyenne Transfer Company, which handled coal; and Cheyenne Ice Company, all listed in the 1902 City Directory. Then the 1910 city directory lists the Coors Brewing Company, which I have also seen in old photographs.

14. OUR PLACE STORE: 321 WEST LINCOLNWAY

When Push Comes to Shove

Our Place is located on the corner of Lincolnway and Pioneer Avenue. It sells many collectibles items, antiques and vintage décor. The 1902 City Directory lists the Golden Beer Hall on this corner and a Bon Ton restaurant near the corner. Frontier Printing, aka Vision Graphics, opened in 1962, and it took up the west half of the block until 2001.

I went in to Our Place and asked if the business experienced any paranormal activity. After getting the skeptical looks that I normally get when I ask that question, I explained that I compile ghost encounters for the trolley tours. They thought it so strange that I came in on that particular day since something had just happened the previous night. They pointed out a section of picture frames and wall decorations that had all been found lying in a different spot when they arrived that morning. They were stacked on each other rather than up against the wall as they had been left the evening before.

Dawn, one of the owners, went on to say that one day her sister was walking into a storage closet behind the register. She tripped, barely catching herself, and she quickly turned around with a scowl on her face. She said someone had pushed her but soon realized Dawn was not close enough to have done it. She said she was definitely pushed, and she had felt a hard shove against her upper back. Sometimes they too smell smoke that cannot be accounted for.

V.
EAST LINCOLNWAY

15. REAL ESTATE OFFICE: EAST LINCOLNWAY AND MORRIE AVENUE

Picture Perfect

For many years, a realtor's office was located in a small strip mall near Holliday Park. Linda was there alone late one night, engrossed in her work, and she flinched when she heard the nearby bathroom door open. Raising her head to see who was there, she was aghast by the sight of a misty form coming around the corner toward her. It appeared like fog, a transparent white color. The misty form was distorted but the size of an average woman. Linda froze in terror; she literally could not move. After a minute, it dissipated, and she bolted to her car.

Linda mentioned the experience to the brokers. While they had known the place was haunted, they didn't want to frighten anyone, so they kept it quiet. Linda made sure she was not in the building after dark, although she actually worked in the building for many years to follow. There were several minor things that occurred over those years.

After a decade, Linda appreciated the corner office she now occupied. At the end of a workday, she was chatting with a co-worker sitting across the desk from her as she was gathering her things. She was speaking when she noticed the color drain from his face. He pointed behind her. The

framed photo of her family had been sitting on the shelf. The frame levitated up, turned over and now lay face down on the shelf. Linda found this very disturbing.

Research turned up a tragic death at this location. The August 28, 1912 *Wyoming Tribune* had an article stating that twenty-nine-year-old Miss Fannie Brook died at three o'clock in the morning. She had been badly burned when she was cleaning a hat with gasoline, and it caught fire from the lamp she was using. She was a beloved young woman who suffered greatly in her death.

VI.

SEVENTEENTH STREET

16. DESELMS FINE ART: 303 EAST SEVENTEENTH STREET

Gallery Ghosts

Deselms Fine Art Gallery is owned and operated by Harvey Deselms, who is truly respected in the art community. Entering the gallery on the corner of Seventeenth and House Avenue, you see beautiful works of art in a variety of styles covering the walls. It's a visual delight. The colorful environment makes it hard to believe that there have been a number of deaths here, but this house has a dark history. It was built in 1883, and initially it was the home and clinic of Union Pacific's Dr. Barkwell. Due to numerous severe railroad injuries, many patients perished here.

During the Depression, the home belonged to the Welch family, who ranched east of town. Jack Welch, still a child, worked in a grocery store, and he would bring home the discarded vegetables, from which his mother would make soup. They served it to the poor from their back door in the kitchen. Years later, when Jack Welch had grown up, his friend Frances Brammer moved into the home with him. Brammar was an esteemed photographer for Cheyenne newspapers for fifty years.

The date was October 22, 1965, when eighty-six-year-old Lena Herbert's life was violently taken from her. She lived in the upstairs apartment, and

Deselms Fine Art Gallery. *Jill Pope.*

though her body did not expire until the first of November, her life was over when fifteen-year-old Anthony "Dean" Blankenship walked out her door. This account is all documented on microfiche at the clerk of courts office, docket #11373.

I'll begin with further details of the murder of the frail Lena Herbert. An esteemed Cheyenne lawyer first told me of this heinous crime. He was in law school when the crime was tried but remembered that it occurred at this residence. With his guidance, I was able to dig up the records and newspaper articles that authenticate the story. The elderly woman had been hit in the head and knocked unconscious; she was a victim of rape; and she was beaten, choked and stabbed several times—more than anyone should have to endure. Her son made the gruesome discovery the following day, and she was taken to a hospital with slight breath coursing through her, but she never awoke. My heart breaks for this woman and her family and the horrible and senseless agony they went through. As shocking as the crime was, so was the fact that the assailant was a mere child, a student in the ninth grade. Anthony "Dean" Blankenship was soon apprehended, and without regret or emotion, he confessed to the vile crime. The records say that Dean had very little parental supervision; his parents had divorced when he was seven years

old. He had spent a year in foster care. When his mother remarried, he went to live with them but did not get along with his stepfather. Dean had many priors for drinking and petty theft. In 1964, he had been charged with the sexual assault of an innocent four-year-old girl, for which he received just one year of probation. A mere three days after Mrs. Herbert's attack, Dean was arrested for indecent exposure, obviously a very disturbed young man.

Judge Garfield sent Blankenship to the Wyoming State Hospital for a psychological evaluation. They found him to be without psychosis, stating he was not insane and that he knew what he was doing. Court documents indicate that he showed no anxiety throughout the legal proceedings. He answered questions in a very unconcerned manner. They labeled him with antisocial reaction and sexual deviation. Dean displayed hostility when he did not get his way and showed little or no empathy for others. It was fortunate that Blankenship was incarcerated, for surely he would have continued his malicious crimes. He was found guilty and sentenced to a dismal life of hard labor in the Rawlins penitentiary.

Then there is also the notorious murder of Allen Ross, a film producer whose body was found buried in a shallow grave in the crawl space. This story was featured on episodes of *Dateline NBC* in February 2005 and

Inside Deselms Fine Art. *Jill Pope.*

Deadly Devotion in 2013. More detail on this murder will follow later in the chapter.

One of the artists who displays her work at the gallery brought in a medium who claims to cleanse places of spirits. Harvey has never had a problem cohabiting with the spirits in his gallery, but he allowed her to walk through. At the time, Harvey had not yet learned of Mrs. Herbert's demise in the home. He did know about Allen Ross's murder, but initially he did not share the information with the medium. She told him that there were certainly spirits in the home. She said that all old homes would have some residual energy, but this was more, much more. She asked to go upstairs. When she came down, she said there was a spirit of a woman hiding and scared up there. The woman had told the medium to go away and not to bother her anymore. Harvey was stunned when I later told him about the Blankenship murder.

During a trolley tour in 2005, one of the riders said that he used to be a tenant upstairs. He mentioned that weird things were always happening with the lights. He was an electrician, so he was able to discern what was caused by old wiring and what was unexplainable. Interestingly, the upstairs tenants in 2007 reported seeing a phantom cat on a regular basis. They also had doors opening on their own.

Returning to the Allen Ross murder, the story unfolded like this. Allen was a filmmaker living modestly in Chicago. Friends described Allen as a quirky, artist type who was charming, sincere, hard-working and witty. In 1992, Allen met Linda Greene, and his life would be forever changed. The two quickly became a couple, and he seemed enamored by her. Before his family and friends knew it, he was moving to rural Guthrie Oklahoma with Linda, though none of them had even met her. Allen stayed in touch, often sending postcards and calling on holidays and important occasions. In the fall of 1995, Allen was doing a film with friend and colleague Christian Bauer in New Orleans, this being the seventh movie they had collaborated on. Linda showed up unannounced and whisked Allen away. Christian was surprised by her personality. He found her demanding and controlling, not at all what he had expected. Allen acted submissive toward her, which Christian thought to be out of character. That would be the last time he saw Allen. In April 1995, Allen and Linda, along with Linda's ex-husband Dennis Greene and her wealthy best friend Julia Williams, moved to Cheyenne together and rented the cute white house at the corner of Seventeenth Street and House Avenue. Allen's family knew something was seriously amiss when he failed to contact his twin brother's on their birthday. Then Thanksgiving and

Christmas went by with no word from Allen. Police searched the home after Allen's twin brother called and reported him missing. They found nothing. Time dragged on with no word from Allen, and it was as if he had vanished. His family hired a private detective and a psychic. Christian and some other friends and family rallied, investigating on their own. Things seemed grim after his car and camera were located in Oklahoma. Five years passed. In July 2000, Allen's brother called Cheyenne police once again, and he was so insistent that they agreed to search the home one more time. When they entered the crawl space, they noticed a black tennis shoe sticking out of the dirt. Allen was finally found.

It was uncovered that Linda was the cult leader of the Samaritan Foundation, an offshoot of the Branch Davidians from the Waco massacre with the FBI in 1993. She had over fifty followers in her sect. Allen was grieving the recent death of his mother when he first met Linda, and she honed in on him when he was vulnerable. I've heard that Linda believed she was a vampire. She made all her decisions with a pendulum, even what to wear each day. When she held the pendulum over a United States map, it stopped over Cheyenne, so they packed up and moved immediately. She was able to lure Allen and many others into her strange world, having some uncanny hold over them. It turns out she was also involved in bank fraud. A few weeks after Allen had gone missing, Linda's family had her committed to a mental hospital. She was released well before his body was found. The coroner revealed that Allen's genitals had been cut off, and he had been shot point blank in the head from behind with a nine-millimeter gun. It was definitely a homicide.

When the police finally found Linda, she was going by the name Genevieve. She gave many different accounts regarding Allen's murder. In one, she said the CIA had taken Allen, but she also tried to lay the murder on one of her five ex-husbands, Dennis Greene. Linda and Dennis were the primary suspects, and they accused each other of the murder. When questioned, Dennis told police that Linda had admitted to him that she and Julie had shot and killed Allen in the living room of their Cheyenne home on November 22, 1995. The police had a hard time sorting out fact from fiction, as Linda's ramblings continually changed. The police uncovered a couple interesting facts, however. First, they learned that Linda's teachings included the instruction that the way to kill a zombie is to cut off its genitals. It was uncovered that Linda owned a nine-millimeter handgun. Julia said she witnessed Dennis shoot Allen, and she helped him move the body to the crawl space, but there were a lot of holes in Julia's account. They learned

that Allen had wised up and was going to leave Linda and the Samaritans; this was Linda's motive for shooting her common-law husband. Before the police pressed charges, Linda died of liver failure. Her family said she drank heavily to quiet the voices in her head. Charges were brought against Julia for aiding and abetting, and she received eighteen months in prison. Dennis was not charged with anything. He had a receipt from a Colorado business dated the day Allen died proving he was elsewhere. He was cleared of the crime.

Our trolley driver Val Martin interviewed a man who had worked next door to the house where the body was found. He had worked there for twenty years, and he said that for five years, he had noticed an anguished moaning sound coming through the sealed-off tunnel in the basement that had once connected his building with the one to the west. Unsure what it was, he never felt scared; it was just something very unusual. Some days it was so prevalent that he would tell his wife about it after work. Once Allen's body was unearthed, the moaning stopped. He understood then. Allen had desperately been calling out, knowing his family and friends were searching for him. Now he could rest.

One Thursday evening just before Halloween in 2001, Harvey was hosting an artist's painting class, which I attended. Once the artists were situated in the gallery and sketching the silhouette of the model, Harvey busied himself by putting up Halloween decorations. He slipped outside and placed a battery-operated skull under the front porch. The moment he set the skull under the porch, all of the lights in the gallery went out. The artists were a bit alarmed when darkness blanketed the gallery. Harvey hurried inside and told us to hang tight; he fumbled through the darkness and flipped the breaker to no avail. He wasn't sure what to do next. Then Harvey said, "You don't suppose…" as he cautiously made his way back outside and retrieved the plastic skull. Immediately, the gallery was flooded with light, and the incident shed light on the existence of life hereafter. The group could not mask their shock. The artists were left to draw their own conclusions.

The popular television show *Dateline NBC* got wind of Allen's murder and came to Cheyenne to do an episode on the case. Harvey said the film crew was really nice, and it was kind of fun to participate in making the episode. They had done the majority of filming and interviewing but wanted to get some final shots of the grave site in the crawl space. Harvey was on the main floor doing some routine tasks when he saw the cameramen sprint out of the gallery, jump in their vehicle and peel out. They were gone. They hadn't said good-bye, thank you, nothing. They had all gotten along well; it was obvious

something had frightened them enough to bolt. The episode aired February 25, 2005. It's surreal to watch and realize that this all transpired in our nice, calm town. Cheyenne has a very low crime rate, so it is strange that two of its most heinous crimes both happened at this small, inconspicuous home.

I introduced Harvey to Cheyenne Paranormal Investigations (CPI), and they agreed an investigation was in order. Infrared cameras were positioned around the grave area in the dirt crawl space where Allen's skeleton was discovered. They also placed them in the kitchen area and upstairs leading to the apartments where Mrs. Herbert's murder transpired. All of these cameras are connected by fiberoptic lines that go to the DVR recorder. The cameras also record digital audio and have built in motion detectors, which is transmitted to the screen of the monitor. Multiple mobile DVR cameras were also used.

At nightfall, the investigation began. Two of the investigators spent a good portion of their time at the grave site doing electromagnetic field (EMF) and electronic voice phenomena readings. After a while, they both heard a soft whisper in their ears and could feel a small breeze wisp over the same ear. They also heard some noises of metal tapping together. An investigator caught sight of a dark object fleeing past him in the living room where Allen was shot.

Our local television station, KGWN Channel 5 news, came to film the investigators at work. When the photojournalist went into the crawlspace with the team, he said, "Doesn't this really creep you out?" The investigator turned to respond, but the journalist had already retreated back upstairs. Not the first time a camera crew has left there in a hurry!

Before the investigation began, all the lights inside and outside of the gallery were turned off. Halfway through the evening, the outside lights came back on by themselves.

At one point, two of the investigators were alone upstairs. As one of them passed by the apartment doorway, the lock unlatched, and the door mystically opened without any human assistance. The clink of the latch turning and the creak of the old door opening was captured on audio from the handheld DVR that the investigator was carrying. When reviewing the video, the team could hear the door unlatch and open, and the investigator was recorded uttering, "Did you hear that?" An infrared camera had previously been set up in that area. The door is clearly seen opening at the invisible hands of something unknown. The current tenants in the apartment said they experience similar activity frequently.

17. KNIGHTS OF PYTHIAS: 312 WEST SEVENTEENTH STREET

Casket Case

In 2010, I met the Paranormal Investigation Team Wyoming (PITW). I was quite impressed with the group. They came across as grounded, intelligent people. This group had focused a lot of its time on the Knights of Pythias Building, and I was thrilled when they agreed to share their findings with me. The team members were Jason, Justin, Jamie, Chris and Ericka.

Mike and Marianne, the building trustees, and the PITW members met me at the building. I had been in the street level of the building, which is a flea market, but had never been in the second floor or basement. I was in for a treat. We entered into a very high, steep stairwell through an exterior entrance. The stairs had an old wheelchair lift installed on the left side, which wasn't operable anymore, and it really put off a creepy feeling in the dimly lit staircase. I felt as though I were in a Hitchcock movie. At the top of the lengthy staircase, we walked through a small entranceway into a foyer room. There were a couple display cases, one showcasing various antique medals and pins and another containing Senator Francis Warren's membership certificate and an old roster, a jeweled membership sword and other memorabilia. I immediately noticed the elaborate textured wallpaper that, while painted over, it is still a reflection of the time of construction, having been built in 1884. The Cheyenne's Knight of Pythias Order #122 has always been in this location. Records of the order show many community events were held here, and the ninth and the sixteenth territorial legislature convened here.

PITW members escorted me into the main hall. I stood in amazement on the beautiful hardwood floors. The room was far more elaborate than I had expected. The members of this order have gone to great lengths to keep the integrity of this hall in order. It features very high ceilings adorned with elaborate white hand-forged copper tiles, with trim work of an elegant gold. At the north end of the hall is a stage for the ceremonies and plays put on by the order. Large curtains are draped at the rear of the stage. Mike informed me that this stage was added in 1922. The west wall displays pictures of the many prominent members through the century. It seems that anybody who was anybody in Cheyenne's history was a member. To the right are several sets of immense tall wooden doors. Through these you can enter into the dining hall. Along the wall are beautiful wood carved

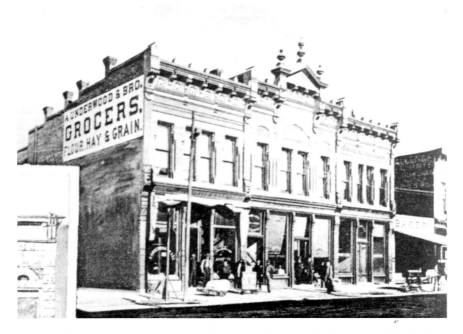

Knights of Pythias block. *Photo from Wyoming State Archives, Wyoming Department of State Parks and Cultural Resources.*

benches with black padded seats. North of the dining room is a kitchen and storage rooms. I can't believe we have this treasure hidden away from all our residents. I think there are very few locals that know this jewel exists behind the blue modern façade.

The history of this society permeates the space, as felt as we walked across the room. We ascended the few steps up the stage. Behind the curtains are props for various ceremonies. The light comes through the alley-side windows that are installed across the north brick wall. To my surprise, there are several little trap doors on the floor of the stage behind the curtain. They used these doors for props during ceremonies. Mike tells of a time when he discovered a trap door that he hadn't realized was there. As he was cleaning the stage floor, he leaned on a section of wood flooring and it moved. Once opened, it led underneath the stage. He crawled in and was alarmed to find an old casket hidden below the stage. He wasn't sure what to do, so he called in some long-standing members so they could open the casket together. Their fears were justified: there was a body inside, which was turned over to a local funeral home. The casket remains in the building. It was determined that this was the body of a young lady around the age of fifteen, and she had

been left to decay in the casket for around fifty years before being discovered. They consulted the oldest member of the fraternity, and he knew nothing about her existence. Her identity is unknown to this day, a lingering mystery.

A hallway connects from the right rear side of the stage, where there are several small storage rooms. This is an area where they experience a lot of activity, hearing various noises and footsteps. There's a paddle lock on one of the storeroom doors that frequently jiggles on its own. This hall leads into the kitchen. Jamie of PITW relayed a story of a time when he was sitting at the kitchen table. He heard footsteps coming down the hallway and went to the door to see who was there. He saw nothing but heard and felt something brush by him. Oddly, he could hear noises and feel something at all three of the entrances to the room, as if he was surrounded by spirits, death coming to life.

PITW let me listen to audio from their paranormal investigations. I clearly heard footsteps and voices. These were recorded during the night when the building was empty. The voice I heard on two separate recordings was male. The first recording sounded like three words, and the last word was "mine." The second recording was more of a whisper but was definitely words, although I could not make out exactly what was said.

One night, Jason of PITW realized he had left his laptop here, so he came back up at twelve-thirty in the morning. Once he hit the landing, he heard a loud conversation in the kitchen and wondered who on earth was there. He yelled out, and the talking ceased, and then he heard footsteps. Feeling leery, he mustered the courage to tread forward to the kitchen, which he found to be empty. He scooped up his laptop and left post haste.

While using their temperature probe, PITW members recorded a thirty-six-degree temperature drop in a matter of seconds. They heard footsteps at the same time. All of the crew reports hearing disembodied voices with the naked ear. Ericka was sitting cross-legged on the floor in the center of the Main Hall. Her hands quickly became ice cold to the point of being numb. They recorded the temperature around her hands, and it had plunged thirty degrees lower than the surrounding area. Once she stood up, they immediately became normal temperature again. The team experiences random cold spots throughout the building. Jason showed me a video where one of the team said it got really cold by him at the same time that they caught an orb on tape.

At times they hear a knocking like someone is at the door, but no one is there. When people have been alone on the second floor, they hear phantom footsteps around them, and they caught these on tape. Jamie and Chris

have had the feeling that someone is standing over their shoulders in the kitchen. They've asked out loud for the spirits to make themselves known and received a knocking response.

Cheyenne Paranormal Investigations (CPI) recorded growling and grunting sounds in the Main Hall on January 30, 2010. Dylan and Scott heard the growling with their own ears. Scott said that he physically felt breath on the side of his cheek as he heard the growl. Simultaneously, they captured an orb, recorded a sound, got something moving on video and had a team member see something. When Scott was standing in the middle of the room, the video recorded something streaking up from his head, and the audio caught a moan and then an unusual static sound. Jessica saw the ball of light streak from Scott's head. While Stacie was sitting on the stage steps, she heard several noises behind her. A "no" whisper was recorded from the stage when asked if anyone was there. Bob asked the spirits to tell them who they were, and then he heard a swoosh sound. Whistles were heard by the team throughout the night in the Main Hall. They also heard a faint conversation, as if a television were playing in another room.

One night PITW members set up a few cameras, and then they all left. The camera that was placed at the foot of the long staircase captured an amazing photo of a shadowy silhouette figure at the top of the stairs.

A spirit shadow can be seen at the top of the stairwell of the Knights of Pythias building. *Photo captured by Paranormal Investigations Team Wyoming (PITW).*

There are also areas in the basement where the group conducts an annual haunted house called "Nightmare on 17th Street" for the public. After learning of all of the ghosts in this building, I believe those that attend the haunted house get their money's worth! There is far more than meets the eye here.

I found the basement quite spooky as I worked my way through the maze they had constructed even though there weren't any costumed figures jumping out, no spooky music or screams. It was quite a contrast from the opulent upper floor to the gloomy basement, yet it was encased within the same exterior walls. There were some gory skulls and blood on the walls throughout the maze, leftovers from last Halloween. It would be easy to lose your way down there.

Numerous orbs are caught in the photos and videos taken in the basement. A little girl's voice is heard, and visitors have also felt tugging on their pants, as though a child is trying to get their attention. Footsteps are heard overhead when no one is upstairs, along with the sound of a chair dragging across the room. They felt touches and breezes with nothing to attribute them to. There are very high EMF readings in some sections of the basement and many cold spots.

The haunted house crew assigned names to different sections of the basement. Five staff members were there working in the Maze Master area one night. They all saw a shadow person, and at the same time, a very tight-fitting door opened and closed unassisted. They've seen the shadowy figure in the Hell Raiser section also. Robert has felt as though he was being touched and heard voices when no one was there, and Stacie of CPI also felt something touch her here.

The Changing Room is where the staff gets ready for the Haunted House tours, applying makeup and donning costumes. This room is full of spirit activity; every investigation here has picked up a lot of abnormalities. People often smell cigarettes and the aroma of pipe smoke here.

The Moms Room is actually situated below the sidewalk. PITW has taken several sound samples of people walking above so they would be able to rule out normal activity from the paranormal. PITW members were in the Moms Room when they heard unusually loud footsteps from above, a clomping sound. What struck them was that the footsteps went north into the main level of the building, despite the fact that the flea market was closed and locked up tight. If someone walked north, he would hit a brick wall, yet the footsteps were moving north into the opposite side of the wall. Customers of the haunted house say they have been touched in this room. It is against the policy of the haunted house for staff to physically touch any

of the customers, and all the staff firmly denies doing so. It made the staff uncomfortable that the customers had experienced this.

One room contains a scene of butchered, bloody limbs hanging and protruding throughout the space. A former staffer actually brought in about two wheelbarrows full of dirt from the graveyard. He was very concerned about authenticity. Since that time, there has been excessive spiritual activity in that section. The equipment all goes dead when in this space; batteries do not hold a charge. Unexplained footsteps and voices are heard here.

In keeping with the society's mission, the Knights of Pythias always donate a good portion of the proceeds from the haunted house to the community. This provides an annual scholarship for Laramie County Community College.

Mike, the building trustee, says that the building next door—now Bohemian Metals—was once part of the original Knights building. He shows me where there used to be a connecting door upstairs to the left of the staircase on the upper floor. Dr. W.W. Crook owned the building, which he sold to Roedel's in 1889. Roedel Drug was located on the main floor of this building for seventy-seven years (1889–1967). Harrington Furniture was on the main floor sometime after this, but it moved out in 1993.

An acquaintance spent the night in an apartment above Bohemian Metals one night many years ago when he was in college. He said he was petrified. There were crazy noises all night long. He heard footsteps, and doors opened on their own. I spoke to the owner of the store who resides there now. He said there was just one bona fide story that he feels he can say he has no explanation for. He enters his home from a stairwell that ascends from the back of his store. There is not a public access to these stairs, so it caught him off guard when he clearly heard heavy footsteps coming up the stairs very late one night. His large dog also reacted to the sounds, taking a guarding stance by the door, growling with his hackles up. He grabbed a bat for protection. Cautiously, he opened his apartment door, ready to confront an intruder. The stairwell was empty, and now the silence was deafening.

I also have had reports from other buildings on the block. One woman said she took a Polaroid photo of a teenage girl, and as they watched the picture come into focus, they were shocked to see a clear image of a man levitating in the air above the girl. His whole figure could be seen except for his feet. He wore a hat and a vintage suit, which she called a zoot suit.

A 1912 newspaper ad endorsed Madame Winterroth, "the celebrated trance medium and scientist palmist," who set up business in the Knights of Pythias building. Maybe her communing with the dead initiated the spirit invocation here.

VII.
PIONEER AVENUE

18. PIONEER HOOK AND LADDER COMPANY FIRE DEPARTMENT: 1712 PIONEER AVENUE

Foreboding Fireman

Local historian Rick Ammon told me about a fireman who worked at the Pioneer Hook and Ladder, Cheyenne's first fire station. This is just up the street a half a block from the Davis Building. As the story goes, one of the longstanding firemen routinely sat out front of the firehouse greeting everyone who passed by. He was especially fond of children and would cheerfully visit with them daily. The fireman was known to be a kind and decent fellow, so it came as quite a shock when one afternoon he sprung from his chair and shot a passerby, leaving the victim sprawled out dead on the sidewalk. There was no apparent motive. He surrendered shortly after and was sent to the State Mental Hospital.

Stacey works in the professional building here today. She witnessed a male spirit in dark pants and a white button-up shirt as he strode across the office, walking the entire length of the building before he dissipated right in front of her. She did not feel that he was malicious, but it was quite disconcerting. She still feels uncomfortable when there alone.

VIII.
CAPITOL AVENUE

19. DON REY'S RESTAURANT: 1617 CAPITOL AVENUE

Amigo

The Don Rey's restaurant is a family-owned business. Geovana would bring her three-year-old son with her to work. For the past month, he had played so well at his spot over in the corner. He would say he was playing with his friend, although he was sitting there alone with his toys. Then one day she noticed a disturbed look on his face and asked him what was wrong. Fearfully, he pointed up to the corner of the room and said that his friend was hanging from a rope up there. She could tell he was truly upset and not making it up. He has seen the haunting man on other occasions since then.

One afternoon, a man came into the restaurant through the front double doors dressed in a long trench coat. "Seat yourself," Ray, the owner, said pleasantly. "I'll be right with you." The man didn't answer, but looking downward, he selected a spot in the last booth. Ray turned to grab a menu and a glass of water. He turned back around so he could assist this customer only to find he was gone in that split second! Neither of the two employees could figure out how he had simply vanished. There was no way he could have walked out in that short time span.

This building is well known for being the Cheyenne Club, a renowned honky tonk that existed in the 1990s and 2000s. It is currently divided in two sections. The north section, where Drunken Skunk is located, has an address of 1615 Capitol Avenue. In 1902, the Capitol Stables were here. In a 1935 and a 1961 city directory, McMurray Manufacturing Paint and Glass was at this address. The south half of the building where Don Rey's is has a current address of 1615 Capitol Avenue. In 1935, the Betty Jane Shoppe posted a yellow page advertisement for corsets. The 1961 directory listed Hughes Home Acceptance Corporation at this address.

20. WYOMING SUPREME COURT BUILDING: 2301 CAPITOL AVENUE

Good Judgment

One crisp fall afternoon, a young professional-looking man in a business suit walked into the visitor center. He was there to purchase tickets for the popular trolley ghost tours. While processing the ticket sale, he mentioned that he had experienced some unsettling events, thus his interest in the ghost tours. He had been doing some volunteer work at the Supreme Court Law Library located at Twenty-third Street and Capitol Avenue. On his second day working there, he became quite self-conscious. He was eager to impress the staff, but every time he walked down the library aisles, the books would fall off the shelves behind him. This continued to happen, and feeling flustered, he explained this to his supervisor, who had worked there for many years. She laughed and went on to say that the staff was familiar with these occurrences and believed it to be the spirit of the renowned Judge Blume. She said the judge didn't appear to like change because whenever there was someone new, these sorts of things happened. She also said that they often could smell his familiar pipe smoke. They thought it was nice that he continued to oversee things.

I would never want to be disrespectful of the honorable Judge Blume's memory, and there's no certainty that this is his spirit. Doing research on the judge, I found him to be a highly respected attorney, legislator and federal judge who made a significant contribution to Wyoming. He was one of Wyoming's great movers and shakers in the political realm. Blume was born in Hanover, Germany, in 1875, and then at age twelve, his family moved to Audubon, Iowa. Blume entered Iowa University and graduated with a

bachelor's degree in philosophy. With his law apprenticeship, he passed the Iowa State Bar in 1898. He served two terms as county attorney. In 1904, at age twenty-five, Fred Blume moved to Wyoming, serving in both the State Senate and the House. He joined the Supreme Court in 1921, appointed by Governor Robert Carey. Blume was reelected to five successive terms, serving in this position until 1962.

He was a huge contributor to the development of Wyoming law. One of his greatest—yet most unusual—accomplishments was his research and understanding of Roman law. Having taken fifteen years to complete a twelve-volume library on the translation of the Justinian Code from Latin to English, he earned a stellar reputation and lectured worldwide on the subject. These Roman laws are the foundation of our modern statutes, and Judge Blume was instrumental in drafting them. Blume did not retire as chief justice of Wyoming until the age of eighty-eight, and still he continued to spend two hours a day at the office he retained in the Supreme Court building until his death at age ninety-six in 1971. After forty-two years of service, this foremost scholar will always be remembered for his huge contribution to the state of Wyoming and to the country. He is a great humanitarian and an inspiration to all.

The thought of Judge Blume remaining here makes sense. This dedicated man who continued to work through his last breath would not easily walk away from his life's mission. He may choose to remain in the place that was so near and dear to his heart, where he felt comfortable and at ease, continuing to influence the legal process in some positive way. Duty calls.

21. Wyoming State Capitol: Capitol Avenue and Twenty-Fourth Street

Capitol Thrill

As I mentioned in the first chapter, we have heard of a few entities hanging around the state capitol building. The information specialist confirmed that between 1892 and 1905, a family lived in the basement of the capitol. They were responsible for the gardening, custodial work and the boiler. Perhaps members of this family still reside in the capitol, embedded in the fabric of the building. A young lady is seen wearing a nice blue dress with petticoats, walking around the third-floor balcony, especially when the legislators meet. An apparition of a young man who appears to be a stable keeper appears

Reflection of the Wyoming State Capitol building. *Photo by Matt Idler.*

nearly every day. He doesn't send out good vibes, and a silent dread is perceived as he paces up and down the basement halls. The staff hears him trudging up and down the stairs as they work late at night.

Cheyenne Paranormal Investigations who I've often worked with over the past decade received an e-mail from a custodian at the capitol. I will call her Gail. She had worked as a custodian in the capitol for the past four years. Gail reported that she and her coworkers spend the evenings with the spirits, and they've had some perplexing experiences there. In most cases, it was just the feeling of not being alone, seeing movement out of the corner of their eyes and hearing muffled voices—nothing that frightened them too much.

One night, however, Gail was helping her supervisor clean the staircases between the third floor and the dome. She said the east side the stairs is slightly off kilter, making an optical illusion that created a fun-house effect. It was a crazy feeling like she was going to fall. Next they went to the west side staircase. Right away she felt extremely uneasy climbing to the top of the stairs. As she cleaned, the feeling got continually worse, similar to a panic attack. Trembling, it became hard to breathe; she kept repeating to herself not to look up, as she knew there was something there that she did not want to face. She was not ready to take the stairway to heaven. Later that night, they were doing the standard rounds, walking around the outside of the capitol, checking that all lights were off inside and that the doors were securely closed. Gail's supervisor mentioned how the west side staircase felt kind of weird that night; she was relieved to hear she wasn't the only one.

Last spring Gail and Lynn, a co-worker, vacuumed the governor's offices. Gail started

Capitol Building staircase. *Matt Idler Photography.*

with the center conference room working out to the west entrance, while Lynn began in the office east of the conference room toward the east entrance. They shut the lights off as they went, so as not to walk back over the pristine wool carpet and leave footprints. Lynn called Gail's cellphone saying Gail had left a light on in the conference room. Gail thought this odd since she distinctly remembered flipping the switch off. Gail went back to shut it off, and Lynn was standing at the east door to the room and watched her turn out the light. She re-vacuumed her footprints and continued on. Once again, doing the security walk with her supervisor and Lynn, they saw a light on in the center conference room. Gail told them that she had shut that light off twice, and Lynn remarked that she had watched her turn it off. The three of them headed back to the governor's offices, a bit unnerved, but laughing about the situation. There were no footprints in the carpet, not even by the light switch. She turned the lights off for the third time that night and said out loud, "OK now, whoever is playing with the darn lights, you can stop it now…you are getting me in trouble!" It never happened to her again. Maybe this was a dedicated spirit who was just working late.

IX.
CAREY AVENUE

22. City News and Pipe Shop: Eighteenth Street and Carey Avenue

Not to Be Ignored

The City News Book and Pipe Shop has regular disturbances. This store is located on the main floor of the Boyd Building. Originally built in 1912 as the Citizens National Bank, it closed a dozen years later. After the bank closed, the south side of the main floor became a drugstore. The building was renovated. In 1925, H.N. Boyd purchased it and relocated his Boyd Cigar Store here. The upper floors contained offices, which are still being used for that purpose today. Purchased by Arthur Putnam in 1969, it became City News and Pipe Shop. Putnam sold the building to Pete Cook in 1974, and it was given a facelift. City News Book and Pipe Shop still operates here, approaching fifty years in business.

The manager told me that they believe their spirit is a male entity, possibly the doctor who worked in the building years ago. She states that every employee in the past several years has had experiences with the spirit.

During the opening process each morning, the ghost sets off the security panels. Employees hear the alarm going *beep, beep, beep*, which it's not supposed to do. When they say, "Good morning" or "Hello" to their ghost, the beeping always stops. If they don't greet him, the beeping continues. When this first

City News & Pipe Shop/The Boyd Building. *Visit Cheyenne photo collection.*

began and they weren't sure what was going on, they kept calling the alarm company, which repeatedly said it did not register a security problem.

The store carries a children's book that has buttons to push to make various animal noises. Sometimes it continually quacks or moos despite being closed and undisturbed. When an employee says, "Hello," the quacking immediately stops. This ghost does not like to be ignored!

The staff often finds entire sections of books turned around. Initially, they assumed a customer was responsible. The staff began watching closely but could never catch the guilty party, even though it happened a couple times a day. Before closing they'd check over the displays and set the alarms. In the morning, the books were turned around again.

One employee heard whispering coming from right behind her, but she turned around and no one was there. Frightened, she left the store immediately. Several doors have been heard slamming when no one is there. Of the spirit, the manager says, "We feel it's attached to the buildings. It's not harmful, just letting you know that it's there. As soon as you acknowledge it, it stops."

Cheyenne Paranormal Investigations set up here. The group caught a few strange noises and environmental oddities. A couple of whistles were

recorded by the Café Bar, and there was a temperature fluctuation of twenty degrees, but nothing too dramatic.

Is it coincidence that every woman who has worked in the coffee shop the past few years has become pregnant? Five pregnancies in two years, and every one of them had a baby girl.

23. MRS. DRAPER: 2116 CAREY AVENUE

Window to the Past

In 2003, the stately Draper House was said to be beyond repair and was razed. The home had been located at 2116 Carey Avenue, where the street was once lined with the manors of prominent Cheyenne founding fathers. Over time, the home decayed, and Harry's Pizza was built directly in front of it. In its day, this large elaborate home was full of activity. Built in the 1880s for the George Draper family, the house later served as the governor's mansion for William Richards from 1895 to 1898. It also housed an Episcopal church parsonage. Mr. Draper was elected to the territorial legislature in 1877. He was the proprietor of Draper & Hammond Hardware, which enjoyed great success supplying the gold rush crowd in the 1870s. The home had wall-to-wall carpet, a true luxury. The Drapers held lavish parties and dances that were hard to surpass for the top society members.

In modern days, the Draper home was positioned beside a federal office building before it was razed. Two women who work in the building each tell of sightings of a woman they assumed to be the spirit of Mrs. Draper. Initially they kept their observations to themselves, afraid others would think they were unstable. Eventually, the women realized they both had seen something at the Draper home. Comparing notes between the two employees, it's astounding how similar their experiences were. They had each seen a woman in a calico dress sitting by the window on the second floor on numerous occasions. She was gracefully brushing her long, flowing dark hair. She looked down on them and smiled.

One of these women was allowed to tour the building before it was torn down. She was so intrigued by this spirit. She somehow felt a camaraderie toward her. Upon entering the upstairs room where the apparition of the woman had been, she noticed a deep impression in the chair by window, as though someone were seated in the chair at that moment.

Draper house. *Photo from Wyoming State Archives, Wyoming Department of State Parks and Cultural Resources.*

On the dreaded day that the wrecking crew arrived, the two employees stood helplessly by. Once again they saw the woman in the window. She extended her arm and gave them a slight farewell wave. The women felt great emotion, and tears welled up in their eyes.

Digging through our archives, we pulled out a photo of the home. In the photo, Mrs. Draper and two of her children were standing on the porch. The two witnesses were moved when they saw the familiar face of the woman they'd seen so many times sitting by the window.

24. CHEYENNE FRONTIER DAYS OLD WEST MUSEUM: 4610 CAREY AVENUE

Mystery at the Museum

Cheyenne Frontier Days is a rip-roaring time. It's the world's largest outdoor rodeo, tagged as the "Daddy of 'Em All!" The ten-day festival includes nine rodeos, night concerts and entertainment, parades, pancake breakfasts, a

carnival, a world-renowned art show and lot of cowboys. This event began in 1897 and has been going strong ever since. The Old West Museum is open year round and features exhibits from the past century of the rodeo and events. The museum is located at Frontier Park, not far from the rodeo arena. Sometimes ghosts come with antiques, so I'm not sure if the ghosts at the museum are associated with this specific location or if they came with one the many carriages or artifacts.

In 2006, we interviewed several staff members, and they all concurred that they have a visitor from the other side. They told of sightings of a distinguished-looking gentleman who appears to be from the 1800s. He seems like a regular person until you approach him and he vanishes. An employee saw the gentleman peering into a display case that contained fishing rods and photos from the late 1800s. The museum was not open at this time, so the employee walked toward him to assess the situation as the man walked on. He turned the corner, and she was quick on his heels, but once she turned the corner, she was alone. The janitor saw him at five in the morning when no one else was around. He went toward him, but again the man vanished.

Riley was settled in at her desk doing never ending paperwork. She noticed that someone in black had just entered her office. She looked up from her

Old West Museum. *Photo by Matt Idler.*

work to greet the person, but no one was there. Employees and volunteers alike have seen a shadow figure walking beyond them. Sometimes they are jolted out of their thoughts as they walk into extreme cold spots.

A former manager was actually snowed in at the museum one stormy winter night, and he ended up sleeping in his office. He swore he would never again spend another night in that building, indicating that he was truly frightened and didn't sleep a wink.

Temperature and humidity control are very important to preserve artifacts in museums. The maintenance room is the pulse of the building. There is a theory that spirits thrive on energy, and that's why batteries are often drained when spirits abound. The maintenance room is where the majority of paranormal activity occurs. The door into this room is always locked. Once inside the maintenance room, there is a separate small electrical room with its own substantial door. To enter you have to turn the knob and pull very hard to open it. The security system cannot be enabled unless this door is tightly shut. The system was armed in the evening as usual, but at five-thirty in the morning, the alarm went off.

The manager and other staff arrived to find the outer door was locked as it should be. Once they entered the maintenance room, however, they

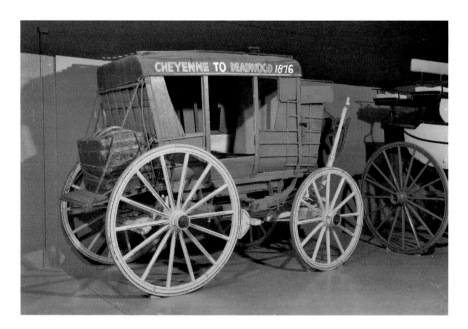

Carriage at the Old West Museum. *Photo by Matt Idler.*

found the heavy inside electrical room door wide open. This happened on a few occasions.

The museum was hosting a large quilt show. Riley was still working on the exhibit at eleven o'clock that night when her husband came by to check on things. The opening of the show was the next morning. Riley was proudly showing him her display. Naturally, they were the only people left in the museum at that late hour. Suddenly they heard a door open and then slam shut. She called out, wondering who would be returning to work at that late hour, but no one answered. Curious, they looked around but saw no one. After a minute, they turned their attention back to the quilts, and soon they heard a door open. They looked at each other, anxiety building, and a moment later, the loud slam rang through the space. They didn't waste any time leaving. The parking lot was completely empty when they left.

An employee was closing up for the night and was walking across the concrete floor of the Carriage Hall when he heard footsteps behind him. He stopped, and so did the footsteps. He took a deep breath, and with great trepidation, he inched forward; again, he heard the footsteps against the concrete. It sounded like someone wearing boots was following him, but he was the only person in the building. He felt the hair on the back of his neck rise, and gathering his courage, he walked on. The echoing footsteps continued behind him all the way across the building.

All costume and clothing items are stored in the textile room located off of the museum offices. The door has a heavy latch that automatically locks when it closes. There is a hydraulic arm at the top that causes it to open or close very slowly. An employee came into the office and saw that the door to the textile room rapidly opening and closing. The alarm was set but not alerting. He stood there in awe. Once it stopped swaying, he approached the door and tried to move it like he had witnessed it doing. He was unable to get the door to open and close quickly.

It's fascinating that the paranormal occurrences increase around October each year. Paranormal studies show reports of ghosts that return annually to a specific site on a day or season of importance to them.

X.
CENTRAL AVENUE

25. St. Mark's Episcopal Church: 1908 Central Avenue

Stairway to Heaven

I would be remiss if I did not mention St. Mark's Episcopal Church in this book. It is Cheyenne's most famous ghost story, one that always pops up if you do an Internet search for Cheyenne hauntings.

The church was built in 1868 at the corner of Nineteenth Street and Central Avenue. In 1886, the congregation decided to enlarge their house of worship, adding a tower to replicate an elaborate British Gothic–style church. This style of stone masonry required someone skilled in this type of work. Two Swedish immigrant stonemasons were located to do the work, and neither spoke English.

When the tower had reached forty feet aboveground, one of the masons did not show up for work. The second mason could not communicate with the locals, but he seemed nervous. The next day, the second mason also vanished. No one knew what happened to them. The steeple had not been built yet, and the congregation was forced to simply put a roof over the incomplete tower. They made a private study for the elderly rector George Rafter on the ground level. He often heard hammering sounds and muffled voices within the tower. George actually discontinued using the room

St. Mark's Episcopal Church. *Matt Idler Photography.*

because of this. Later, a pipe organ was installed in the former study. In 1927, a bell tower was put in rather than a steeple. The tower was built up to sixty feet, and then eleven carillons that weighed nearly twenty tons were installed. The workmen complained of eerie happenings to the point that construction ceased several times. The workmen strongly believed that if they accommodated the ghost, it would be friendly. They convinced the Reverend Charles Bennett to allow them to build a private room for the ghost inside the tower. They plastered and laid flooring and even hung a chandelier in the room. The room could only be reached by ascending the eighty-five-foot-high spiral staircase from a private entrance in the basement.

In 1966, Reverend Eugene Todd was sent for by a patient at a Denver nursing home. An old man shared knowledge of the stonemasons' fate with Father Todd. As a child, this man lived in South America. He had known one of the Swedish masons who worked on the tower so many years earlier. He explained that the mason panicked and left when his fellow mason tragically slipped and fell to his demise inside of the tower. Afraid he'd be deported or incarcerated, he stuffed the body in an unfinished wall section and laid cement, entombing his friend's body inside the tower for all eternity. He fled, afraid he would be accused

105

of murder, and eventually ended up in South America. Reverend Todd admitted that all the details of the story matched the church's records and said he had personally experienced the ghost.

In 1979, the bell tower was opened for public tours. For fifty cents, people could enter the basement door to the long, winding spiral staircase and climb up the tower to the ghost chamber where the guide would tell the ghost story before heading up one more flight to the carillon room to see if you could hear the ghost. Revered Todd said morticians have told him that the body would be totally mummified in the cement. Dozens of parishioners have reported strange voices and experiences over the years.

Lou Wright, a popular psychic from Denver, along with a Cheyenne radio DJ, spent the night in the room one Halloween broadcasting a radio show. As Lou climbed the staircase, she was overwhelmed with a feeling of dread. After Wright and the DJ were set up in the room, Father Eugene Todd locked the doors and left. Lou sensed a frightened, upset spirit and a second spirit of a white-haired man who used a cane. He was later identified as Father Rafter. Looking out of the window, Lou Wright saw balls of white light dancing around the outside of the church. She said she saw blue lights climb the stairs to their room, and a slimy substance began to ooze from the room's baseboards. The clarion bells began ringing by themselves. A rough man's voice shouted at them, "Get out of here while you still have your mind!" The DJ called for help, and fifteen minutes later, they hurriedly exited the church. Twenty minutes later, the church bells began ringing by themselves once again. Police thoroughly searched the church and grounds and could not find any pranksters. The floor was covered with a white dust-like substance.

Tours are no longer being offered. In fact, the church has changed its tune on the story and prefers not to promote it. The story had received national attention, which the church authorities felt had a negative effect on the church. They say the tower is boarded off because the stairs are unstable. Strange occurrences continue to happen. A voice from the unusual tomb is often heard. Organ music floats through the air, lights go on and off and objects disappear and turn up somewhere else. Trolley riders that live nearby have told us that they hear the organ playing at two in the morning.

I read a local Facebook post in which a man commented that he had attended preschool at St Mark's and thinks it's haunted. He said that his Play-Doh used to fly across the room.

26. FRONTIER HOTEL/SUITE BISTRO: 1901 CENTRAL AVENUE

Two Ghouls and a Guy

Across the street from St. Mark's church is the Frontier Hotel, built in 1937 and embellished by lovely art deco design inside and out. For a period of time, the hotel served as a retirement home. In the past decade, the hotel was refurbished into modern apartments. In 2007, I spoke with three separate tenants who relayed spirit activity to me. They frequently heard a child running down the hallway of the fifth floor. No children reside up there, and when they look up and down the hallway, there is no child to be seen. One man watches his apartment door open and close on its own while he is sitting there watching television. Fleeting shadows are often noticed. I was recently told that current residents continue to experience all of these things.

A lot of paranormal activity has been experiences in the lounge Suite Bistro, which is located in the Frontier Hotel building. Stephanie, the bar manager, said they had two psychics and a paranormal team from Denver

Room in the Frontier Hotel. *Jill Pope.*

come in to evaluate in 2012. These experts expressed that there is a lot of paranormal activity here. With the information compiled, Stephanie says the experts and the staff have concluded that there are three entities in the lounge.

She said that a man leapt to his demise from the third floor in the 1930s. They say he doesn't like their music, except when they play oldies. Both psychics spoke of this fellow. One afternoon before the bar was open, Stephanie pulled up a stool in the center of the bar and spread out her paperwork. She found it easier to do this task when no one was around to interrupt. Absorbed in her work, she was startled when a stool at the south end of the bar wiggled, as though

Suite Bistro. *Matt Idler Photography.*

someone had just stepped up. Before she could process that, the stool at the very opposite north end of the bar tipped over, loudly crashing onto the floor. In a couple seconds, the door at the end of the hallway slammed closed, with all three actions happening consecutively. She was so scared that she called her boss to come in. A couple people have said that they were shoved while going down the stairs. They blame this male spirit for that.

Cori, another employee, said that recently she and Jesse were there closing up. It was one in the morning. She went to get trash bags and was standing on a lower landing when she saw a man in black dress pants and a crisp white shirt walk past. She thought nothing of it because Jesse was wearing black pants and a white shirt. In a moment, she went up the few stairs and then walked down the same hallway but went the opposite direction. She was shocked to run into her co-worker since she had just encountered a man going the opposite direction. They double-checked that all the doors were locked and concluded it must have been a ghost.

A young female spirit who has been heard in the apartments also visits Suite Bistro. Stephanie says the girl likes to mess with her. She shuts doors

and turns off lights when Stepanie is in the basement. She hears the little girl giggle and says this is a common occurrence.

The management was told of an older woman who hung herself in the 1980s when the former hotel was a residence for the elderly. Her apparition has been seen walking down the stairs, and they feel her around them. She had a different vibe than the angry male spirit.

Stephanie said the paranormal investigation team from Denver captured audio recordings of a man and a woman talking. She said the man said he had worked at the hotel.

27. TERRY BISON RANCH: 51 I-25 SERVICE ROAD EAST

Paranormal Border Patrol

The Terry Bison Ranch is located about eight miles south of town, situated on the Wyoming-Colorado border off of Interstate 25. It's been jokingly said that the bison are our border patrol.

Charles Terry was the original owner of Terry Ranch, as it was known when Frances Warren purchased the ranch from Terry in 1885. Francis Warren is one of Wyoming's founding fathers. He was the last Wyoming territorial governor and the first State of Wyoming governor. The Warren Livestock Company ran cattle and sheep and also bred sheepdogs at the Terry Ranch. By 1909, Warren was the richest person in all of Wyoming. He had his hand in many different spots and was a smart businessman. President Theodore Roosevelt visited Cheyenne and stayed at the Terry Ranch as a guest of Warren's. Another frequent visitor of the ranch was the prominent general John "Blackjack" Pershing.

In 1964, an excavation at the ranch by the Cheyenne Archeology Association found evidence of three separate Indian tribes there. Hundreds of articles, including ceramics, projectile points and tools, were recovered. There are indications of many explorers and settlers following the lure of gold. Fur traders temporarily lived in the area from 1828 to 1843, but it was difficult to survive the constant Indian attacks. Most stays were short-lived.

Today, Ronald and Janice Thiel own the Terry Bison Ranch, which is now a popular tourist attraction and a working bison ranch. They own over 2,500 head of American bison. Their son, Dan Thiel, oversees the operations of

Up close and personal with bison on the train tour. *Jill Pope.*

Terry train tour. *Matt Idler Photography.*

the ranch. It's not unusual see to him out working on fencing or some other project at midnight. They laid train tracks around the ranch and run the Terry Train Express for visitors to ride. The train takes you into the pasture, where you are greeted by camel, ostriches, a herd of bison and some steers and yaks. The animals get up close and personal with the visitors. There are many varieties of critters located on the thirty thousand acres of land that overlays Wyoming's southern border crossing into Colorado. There are charming log cabins for rent and lots of RV and tent sites. The ranch includes a fun western gift shop and the Senators Steakhouse, complete with the Brass Buffalo Saloon.

Many employees and visitors have reported a wide range of paranormal activity, so Cheyenne Paranormal Investigations went in to investigate and allowed me to tag along. We investigated five different structures at the ranch.

Bunkhouse

The bunkhouse is a dorm-style, two-story building constructed in the early 1900s for the wranglers and guests to stay. If you want an authentic ranch-hand experience, these are the accommodations you should book. The house has several bedrooms with a common kitchen and two living room areas and community bathrooms. There's a tale of two cowboys who were playing cards upstairs, and one accused the other of cheating. A fight ensued, and one of the cowboys was slain. Many people have reported hearing full conversations with voices of an argumentative tone. Footsteps stomping down the stairs are heard, but no one is seen. Lights turn on or off with no one near the switches, and items in the building are tossed around by an invisible arm. Guests have spoken of their blankets being tugged completely off them. Folks in nearby buildings at the ranch have seen the curtains being pulled back and people looking out when no one is inside the bunkhouse. A lady's voice has been heard calling out, "Larry Henry." One man reported being walked on by what felt like a cat. The activity is the strongest from two to three o'clock in the morning.

Late one evening, a blizzard quickly and furiously kicked up. The general manager and a ranch hand quickly headed for the nearby bunkhouse through the whirling snow, grateful for the shelter. No one else was in the building. Wet and exhausted, they each grabbed a sofa in the dayroom

rather than continuing to a guest room. They were disrupted from their sleep by the chatter of many voices conversing and heavy boot footsteps. All of the lights began turning off and on. The lights are wired on different circuits, so it made no sense that they all did this simultaneously. The men scurried around the bunkhouse trying to find the source and looking for some sort of explanation, but when no culprit was found, they hustled out of the bunkhouse and back into the storm where they felt safer!

During CPI's explorations, the group heard a knocking above them on the second floor. One of the team members went up to explore the sound, and he felt someone unseen push him when he tried to enter the Wild Bill Room. Later, two team members entered this same guest room, and they both smelled a sweet tobacco odor. They recorded a whispering voice in the background, but the words were indiscernible. The audio recorder caught some unexplained sounds throughout the bunkhouse. While downstairs in the left hallway, two of the team members heard a whisper come from one of the guest rooms. Later while reviewing the recorded audio, they heard the word "ghost" being said.

The Senators Restaurant and Brass Buffalo Saloon

The Senators Restaurant at the ranch meets all expectations. It's rustic and elaborate at the same time. The employees fondly call their spirit "Charlie" and think he's a bit ornery. Many people have heard footsteps throughout the building, and sometimes they hear them ascending the staircase or walking the full length of the large building. The aroma of coffee and cigars has been detected at two in the morning when there's none in sight.

Women have repeatedly been locked in the restroom, despite the fact that there is no lock on the door, just on the stalls. They have changed the doorknobs, but it continues to happen. Women have also complained about the restroom stall doors slamming open and shut with them in there. The staff has heard loud banging of the bathroom stall doors, but when they enter the ladies room, they find it's empty. An employee was in the men's restroom one evening and a picture on the wall slapped back and forth against the wall a couple times. They checked for air vacuums but found none.

Very early one morning, a kitchen employee saw an apparition of a small girl standing in the kitchen. The manager was in the upstairs office, and she also saw the girl on the security camera screen, but unfortunately, the tape was not running at the time. The kitchen employee ran outside and waited

Senators Restaurant. *Matt Idler Photography.*

Senators Restaurant and the Brass Buffalo Saloon. *Matt Idler Photography.*

Scott Newberry of Cheyenne Paranormal Investigations at the Brass Buffalo. *Matt Idler Photography.*

for more staff to arrive before reentering. This girl is seen regularly around the ranch.

The general manager has had the lights turn back on after he has locked up. Employees also find flipped-over chairs. The bartender and three others were cleaning up once when they witnessed a bright blue ball of light coming down the wooden stairs. The light appeared to explode; it was so bright that it blinded them for a bit. After it was gone, they saw spots for a while.

One evening, the hostess and bartender were leaning on the far beer cooler talking when a wine glass from the wine rack located over eight feet away came flying toward them, nearly striking their heads and shattering just behind them. Two guests witnessed this as well.

The bartender was once pouring a drink for a guest when a wine glass flew over the bartender's head and broke onto the counter behind him. The guest said, "I didn't do that! Where did that come from?" The bartender replied, "It's Charlie," then went on to explain to the curious customer that they have a ghost or two. He relayed that bartenders often experience brushes against their legs and taps on the shoulder. Recently, a black "spider web–looking"

object was seen floating at about knee level. It floated about twelve feet and then just vanished. Strangely, when CPI investigated they did not find any hard evidence to back up these claims in the restaurant. Perhaps the ghosts didn't feel like playing that night.

The Wine Cellar

The wine cellar at the ranch was built in 1910, and this an underground area is now used as cool storage. There are three floors that are built into the hillside. The little girl spirit has also been seen here, and there have been many reports of unexplained noises. CPI had a series of odd events occur while the group was in the lowest portion of the old cellar. Two team members were sitting in a corner, and at the same time, both of their EMF readers started indicating fluctuations in the magnetic field. Another was using the video camcorder, and every time he pointed it toward these two team members, it would instantly go out of focus. Pointing the camera at other sections of the room, this did not happen. It was as if something was in between the camera and them. The two then started complaining about how cold it was. Another person took a temperature reading and found a twenty-degree difference between the spot where they two stood and the rest of the room. In theory, when a spirit manifests itself, it draws energy from the surroundings. Quite often there is a noticeable temperature drop in an area where a spirit is trying to manifest.

The new batteries in a digital camera went dead without ever being used. The EVP captured what could possibly be a language other than English, perhaps an Indian dialect, which would make sense when keeping in mind that the land had been occupied by ancient Indian cultures centuries ago. It sounded like voices, but the words could not be distinguished.

Wagon Wheel

A hostess was clearing up the Wagon Wheel building after a reception when she found she was locked in the bar area. She tugged on the door while screaming for help. Frustrated, she backed off for a moment, and then she watched wide-eyed as the door unlocked itself. People have seen movement inside when the building is empty and locked. When CPI members entered the Wagon Wheel, the batteries in their audio recorder immediately went

Wyoming state line. Terry Bison Ranch is on the east side of the interstate. *Visit Cheyenne photo collection.*

dead. They recorded a bell ringing and a coughing sound, and neither of these sounds came from the team members.

Several of the summer guests excitedly informed the staff of a ghost, describing him as a male shadow person. He had long hair and wore a hat and a long, duster-style coat. One customer said they had seen him walk around the barn, but when they went in, they found the barn empty. One night an employee noticed a shadow of a man cast from the parking lot lights, but there was no man.

XI.
DOWNTOWN AND RAINSFORD DISTRICT

28. AVENUES HOME

What's Up Doc

The next story pertains to a lovely white two-story home in "the Avenues," an upscale neighborhood just north of the capitol building. The home was built in 1922. Some cultures believe that having a red door keeps the evil spirits out, and I think there's good reason for the red door at this home.

When Kelly bought this home in the 1980s, he learned that there had previously been a doctor's office in the home. Doing some renovations, Kelly was removing the drop-ceiling tiles, and he discovered old birth records and medications. These items were dated from the early 1900s, and the bottles were oozing chemicals. Kelly turned this entire find over to the proper authorities. The fire department came in to remove the drugs, which included strychnine. Kelly said there were sinks in most of the rooms. During the kitchen remodel, he uncovered a built-in cabinet and a set of maid stairs that had been completely enclosed; the stairs now descended into the pantry.

Kelly was alone the first night in the home. Exhausted from the strenuous work of moving, he quickly drifted off to sleep but was jolted awake by a loud crash. When he investigated, he found that the glass globe from the

hanging antique light had crashed to the floor, and glass was scattered throughout the room.

Kelly's son and girlfriend also lived in the home. They felt a presence regularly in the home and knew there was a ghost among them, but still Kelly was overcome with a foreboding feeling when he actually witnessed the misty figure of a woman in period clothing standing beside his infant son's crib. While living here, he saw her specter several more times and came to realize she was looking after his son, and there was nothing to worry about.

By chance, I met a house painter years later who had been hired to help with another remodel of this residence. She came down the stairs and pushed against a swinging door to enter into the adjoining room, feeling a strong resistance against the door. Startled, she stepped back, paused and then pushed against the door a second time. Again, she felt it being pushed back from the other side, but it did open. A cold breeze whipped by her. Overwhelmed by her experience, she went to the owners and shared the happenings with them. They acknowledged that the home was haunted and told of many other incidences they had experienced. The owners told her that the home used to be a physician's office and pointed out the separate entryway where the patients entered. The radio in their daughter's room would turn on by itself, and often contents from the refrigerator would be found on the counter with no explanation. Disembodied footsteps were heard. When they were redoing the floor, they had sheets of particleboard laid out. The footsteps were strong enough to shift the boards as this entity moved across them. They placed the couch on top of the boards. It could be seen teetering as the boards moved, and still the footsteps rang out.

29. CANDI LAND: SOUTH GREELEY HIGHWAY

When Cheyenne was a young city, supplies were brought to the West by railcar. Just after the turn of the century, the first prefab home in Cheyenne went up at 121 West Twenty-fifth Street. It was purchased in Chicago and shipped on the Union Pacific railroad in sections. This lovely large yellow home was originally built downtown but was moved a few miles south of town when the State of Wyoming had the Herschler Office Building constructed on the block north of the capitol in 1978. This home was located half a block from the home in the last story.

Candi and Charlie did not believe in ghosts when they purchased this home to save it from demolition, but that soon changed. This residence

Candi's home. *Jill Pope.*

has been used as state offices and a safe house for battered women. The crazy activity began the day they had the house moved south of town. Candi recorded the event, but to her dismay, the VCR tape was blank when she played it. After the home was secured in its new location, their seven-year-old son told Candi he did not want to move into the house. It's such a great house that they could not figure out why. When they inquired, their son exclaimed, "Because of the gray man in the window waving the lantern!"

Soon the family and their friends came to realize that the home was occupied by former residents. They would often find the front door and tight-fitting windows open when they returned home. They knew they had been securely closed when they left, and there were no other signs of intrusion.

Their brother-in-law was an overnight guest. He suddenly woke up during the night, knowing someone was there, and opening his eyes, he saw a gray man sitting at the foot of his bed. The gray man got up, drifted to the dresser, appeared to set something down on it and then disappeared before his eyes.

On another occasion, their son was home alone when he distinctly heard a man and woman arguing down the hall. Scared, he retreated into his bedroom. More often, they would hear the delightful sounds of children

laughing. The family dogs were in tune with the spirits here. Somehow one of their dogs was able to go in and out of the house although the door was closed and locked. The dogs would often tilt their heads and stare ahead, watching the ghost going up and down the stairs. They would bark at something not seen by the human eye.

One evening Candi was relaxing in the living room when a scream pierced through the air. It was their youngest son. Candi sprinted up the stairs to the bathroom where he was showering. The upset boy asked her to tell his brothers to leave the bathroom doorknob alone and stop teasing him. Candi explained that both brothers were sitting downstairs in front of the television with their dad. For some reason, the bathroom was a very active spot in the house. Another day, Candi had just finished taking a bath and was toweling off. She hadn't pulled the plug to release the water yet. She heard the water splashing so she turned and looked into the tub, where the water was splashing up on its own. Another time she was sitting on the edge of her bed while getting dressed, and she felt a hand caress her back. It was at that time that she told the ghosts to back off.

The most alarming thing occurred when their son was a senior in high school. His friends came to pick him up for a school event, and there was a car full of teenagers pulled up in the driveway. Waiting in the car, the teens heard a noise; they looked up to the sunroof, where they all saw a beautiful woman with long golden hair looking back at them as she floated above them. They jumped out the car and hysterically ran screaming into the house. After this incident, the family went many years without any activity. They felt that the spirits liked being around their children, and once they were older and moved out, the activity ceased. But then one crisp April night, Candi and Charlie had gone to get supplies for their horses. It was dark when they got home. Candi said she would get the horses fed if her husband would unload the two bulky licking stones. She was getting the hay spread about when she saw her husband trudging through the snow, carrying the first block and struggling slightly as he lifted it up and over the fence. A few moments later, she looked over and saw the outline of her husband carrying the second heavy block. She thought it was a strange place for him to be placing the salt block. When Candi turned the opposite direction and walked around the horse trailer, she ran right smack into her husband, who was carrying a block. Caught off guard, she asked how he got there when she had just seen him on the other side. Charlie said he had not been on the other side of the trailer and pointed out that he was holding the second block in his hands. Candi and her husband walked over the area where she'd

seen the male outline. They found no signs of anyone, and there were no footprints in the fresh snow.

Early one morning in May, Candi was in the main floor bathroom getting ready for work. Her husband was in the kitchen cooking up breakfast. He walked into the bathroom and seemed startled to see Candi. When she asked what was wrong, he got flustered and said he had just seen her walk past him while he was in the kitchen. He said out of the corner of his eye he saw her go by and then run up the stairs. While he is not usually easily ruffled, he was quite shaken up as he showed Candi the goose bumps that covered his arms. Candi never feared the ghosts she lives with, as she believes they exist there for a reason.

30. FORT D.A. RUSSELL HOUSE

Mirror Image

In 1976, Anna was looking for a place to live. A co-worker told her of a house for rent. The Victorian home was just a block away from the hospital where she worked. This happens to be one of the homes that was moved off Fort D.A. Russell in the early 1900s and relocated into town. The homes were brought in by horses and steam tractors. Fort Russell was originally a tent camp and was being developed at the same time Cheyenne got its start in 1867. In 1885, Fort Russell became a permanent post, and the wooden buildings were gradually replaced with brick structures. The city purchased dozens of these wooden buildings. Senator Warren bought over thirty of the buildings himself.

The landlord frankly told Anna that the house was haunted. Anna had fallen in love with the quaint home, especially the cozy front parlor that had a fireplace. Anna signed the lease anyway, and her family of four moved right in. There was paranormal activity every single day that they lived in the home. From the master bedroom, they could hear footsteps above. She likened the sound to that of a large dog walking on linoleum, nails clicking with each step. Anna and her husband, Frank, were uncomfortable every time they went to the basement. Like most basements, they felt a cold rush when they entered the space, but beyond that, they could feel a presence watching them. Their blue heeler dog would stand at the top of the staircase and frantically growl, hackles standing on end. Frank thought that if he

This photo shows how buildings were moved with horse teams as many homes were moved into town from Fort D.A. Russell. Shown here is the Black & Tan Club. *Photo from Wyoming State Archives, Wyoming Department of State Parks and Cultural Resources.*

brought the dog down there she would see that everything was fine. The dog put up a huge fight, and despite all his efforts, Frank could not force the dog to enter the basement. Their children were too young to notice anything, but their sixteen-year-old babysitter was scared to death in the home. He even kept a steak knife with him when he was there. They remained in the house for a year and a half, but their reason for moving was not the paranormal activity. I don't know who the spirit residing here may be, but I consider the notion that the ghost accompanied the home from Fort Russell.

Decades rolled by, and Steve and Jeff moved into this same home. Family stopped over to lend a hand with the move, their young nephew Jordan in tow. Jordan was completely fixated on the staircase. When they questioned little Jordan, he said "George" was there. Steve and Jeff later spotted George themselves. He was in a blue military uniform. Whenever they saw him, he would quickly dissipate, so cleverly they placed mirrors all throughout the house with the thought that if they were not looking directly at him, he would not vanish. This actually worked. They were able to view his reflection in the mirrors on many occasions. One time they observed George walking up the front sidewalk toward the home they share with him. Incredibly they found fragments of a tombstone in the crawl space, but unfortunately there were no discernible words on the tombstone to reveal the past.

A trolley passenger said she used to live in this home for about five years as a child in the late 1970s. She also experienced George's exploits here. She saw a male ghost on the stairs sometimes, and she was deathly afraid of the basement—sounds familiar. I am intrigued when I hear similar accounts from unconnected witnesses.

31. For Sale: Home of the Lost Child

At another home not too far away, a group of prospective buyers entered into the small white house on Twenty-First Street. As they approached to unlock the front door, they heard a loud banging and knocking and actually felt the door shake. Sandra asked if someone was in there, but the realtor told them there was no one home. Upon entering, they found it to be empty. One of the ladies went down to the basement, only to be overwhelmed by a negative, oppressive feeling. She rushed back upstairs, proclaiming that this was an evil place, and immediately left. Later, an acquaintance told Sandra that she had a known a previous resident who told her that one night after tucking her children into bed, she fell asleep in a reclining chair in the living room of this house. Her husband traveled for work and was not home. She woke up to find a child, a precious little girl, sitting on her lap sobbing. However, this wasn't any of her own children; she had never seen this child before. It was obvious this pale child was not of this world. She jumped up and frantically gathered her own children, heading to a hotel. They sold the home. Sandra says the house has had a high turnover of owners. No one seems to stay for long; it was for sale again when the story was relayed to me.

32. Spider Maxwell: Maxwell Avenue

The pleasant aroma of pastries and fresh bread surrounds you when approach the charming little house on Maxwell Avenue because there is a bakery nearby. Former homeowner Angie named the ghost here "Spider Maxwell." She smiled when she talked of him, saying she believed he was a child spirit who was a bit mischievous. Angie and her assistant, Beth, set this home up as an insurance office. They entered a small attic bedroom, which had cabinets built into the short, angled wall space. Angie bent down and stuck her head into the cabinet to see how she could use the space. The cabinet was empty. The next day, the ladies carried supplies up to place

inside the cabinet. When they opened it, they found coins lined up in a perfect row. The coins were dated from various years. The deep layer of dust had not been disturbed.

Both ladies would hear footsteps upstairs when just the two of them were there. Beth would not stay in the house alone. If Angie left, the assistant gathered her papers and took her work home. Angie believed the spirit was a child who meant no harm, so she was not afraid. She stayed late one night, preparing an insurance policy for a big client. Once the document was ready, she placed it in the center of her desktop, confident and ready for their morning appointment. But the next morning, the policy was gone. Turning the place upside down, the frustrated Angie had to postpone the appointment. When she came in the following morning, the policy was again placed in the center of her desk, exactly where she'd set it two days before.

Several years later, after the house had been changed back into a residence, I was driving a proposed route to see how it would work for the upcoming trolley ghost tours. I noticed a young woman walking up the sidewalk lugging her groceries. At the risk of coming off as a nutcase, I approached and asked if she lived there. When I explained why, she said that yes, she rented the home. She asked if the trolley tour included her house. When I affirmed this, she giggled. I asked if she had experienced anything paranormal, and she emphatically said, "Oh, yes." She liked the place, saying that it is charming, but she too has often found things moved around from their designated spots. What really interested her was the money story. She was continually finding coins in odd places where she knew there had been none. She claimed to be a very organized person who does not leave change lying around, yet she found coins stacked or lined up constantly. She said in a good week, she makes fifty cents off of the ghost! She believes the bedroom upstairs belongs to the ghost because that is where most occurrences happen. The previous tenant had told her she had things moved around as well. Like Angie, the current resident feels it's a fun-spirited ghost.

33. SNUFFED OUT: EAST NINETEENTH STREET

The *Tribune* in June 1912 carried yet another tragic headline. Following his dreams, Bert Pierce, just twenty-one years old, headed west from Illinois. Bert had secured employment at the Bard Ranch, situated just east of the city and Holliday Park. He had lived in Cheyenne just a couple weeks when a devastating accident occurred.

Bert was leading a horse from the ranch to the Bard home on Maxwell Street. He was nearing Holliday Park. In a costly move, he tied the horse's lead rope to himself, freeing up his hands to light his cigarette. Something spooked the horse, and it took off in fright. Bert was dragged along for several blocks before being hurled against a telephone pole, rendered unconscious. His lifeless body was a mass of bruises, with a fractured skull and his scalp torn loose. This instance is proof that cigarettes do kill!

Bert may be the entity that occupies a home across the street from the park. He keeps the tenants alert. Shad and Chris, two brothers in their twenties, lived in the small white house in the block east of Holliday Park. They had so many ghostly experiences that they invited their pastor to come bless the house. The occurrences calmed down some after the blessing but definitely continued.

About a year after moving in, they asked their buddy Brady to live there as well, warning him of the unseen occupant. Unconcerned, Brady took them up on the offer. The first night Brady stayed there, he was alone when he heard distinct whispering outside his bedroom door. He tried to make out what was being said, but he could not. Brady also heard something walking across the hardwood floors as he lay still, his heart pounding through his

Holliday Park, where Bert was dragged by a horse in 1912. *Matt Idler Photography.*

chest. His friends had warned him there was a ghost residing in the home, but Brady really didn't buy it until then.

That same week, Brady was in the basement doing laundry when it sounded like someone was breakdancing overhead, but again he was the only one home. This became a normal occurrence. They got a new dryer, and the door closed securely. They had to give it a strong tug to open it, but when they did laundry, the dryer door flung open during nearly every load.

Brady was in his bedroom playing Xbox when he heard a loud whistle directly in his ear, making his skin crawl. Two hours later, Brady's roommate came home; Brady was in the kitchen cooking up some stirfry while Chris was hanging in the living room. Chris thought Brady was whistling in the kitchen, but he was not. Five minutes later, when standing beside each other in the kitchen, they both heard the disembodied whistle.

One sweltering August afternoon, Brady was lounging on the couch and Emma, the dog, was napping in her kennel. Shad's bedroom door briskly swung open, alerting both Brady and the dog. The window was closed, so there was no breeze to cause this. The same month, Brady was trying to sleep despite the intense heat. Again, his roommates were not home, but loud boot stomping sounds persisted in the kitchen, and this kept his eyes wide open.

Because of the dancing, whistling and mischievous behavior of this ghost, the residents and I think he may have been fairly young when he passed. The guys continue to experience these unnerving things. So far it's all been harmless, so they went ahead and signed a new lease. Maybe they need a fourth occupant listing on the lease for Bert.

XII.
SOUTH OF THE TRACKS

34. HELP ME: WEST SIXTH STREET

As a collector of unusual and paranormal tales, every now and then there's one that stands out. I'm told many tales of hearing footsteps when there's no one physically there and of seeing glimpses of fleeting shadows or hearing voices from thin air. While each one of those encounters is intriguing and adds to the collective data that validates paranormal activity, there's always a desire to have just a bit more, something to really delve into and investigate. This story fits the bill and comes to us from Henry, a case manager at a correctional facility, a no-nonsense kind of guy who is not prone to embellishing.

A couple years ago, Henry and his friend Ralph were doing a remodel in a small white house in a neighborhood south of the tracks just off of Snyder Avenue (west of the viaduct). This area is known as the Southpark Edition. There's nothing particularly eye-catching or noticeable about the home.

It was a dark, chilly winter night, and a heavy snow was falling. They were working on a plumbing project at the kitchen sink. Henry was sprawled out under the sink, and Ralph was assisting from above. They heard a loud, strange noise and thought someone was entering the home. Ralph looked around and found nothing out of the ordinary. To be safe, he locked the doors, and they resumed their work.

Once again, they heard the loud noise, which could not be ignored. Both men walked through the entire house looking for the source of the noise. They were surprised to find the back door unlocked. Nervous now, they locked the door again; they were anxious, but they went back to work. They heard the noise a third time. Together they checked the back door and found it unlocked. That was all they could take, and they decided to leave so they could gain their composure.

Knowing they would return soon, they left all the lights on, as they did not want to enter a dark house at this point. Henry laid his flashlight on the counter near the door. As they departed, they noticed that there were no footprints in the snow. Once their heart rates had slowed down, they returned to the unassuming home brandishing guns. Approaching the home, they looked for evidence of an intruder. They noted that there were still no footprints in the snow surrounding the home, but what caught them off guard was that all the lights in the home were now turned off, except for the beam of Henry's flashlight that he had left turned off on the kitchen counter.

Henry quickly flipped the light switch on as they hesitantly entered the house. They searched the home, going from room to room looking for intruders with their weapons drawn. They didn't find anyone, but they were too shaken up to continue working. Hurriedly they gathered their tools and headed to the door to leave, but they stopped dead in their tracks paralyzed by fear as they both read the words "HELP ME" etched in the frost on the back door window. There were still no footprints in the snow as they darted to their car. They finished the remainder of the project in daylight hours.

Horror movies with a paranormal angle usually include some word spelled out in blood across a wall, but rarely do we hear of real encounters that extreme. There are some recorded accounts of this phenomenon; it's referred to as "direct writing." The definition reads that a spirit actually writes words on a surface using any means.

The house across the street also has a ghost. The young woman who currently lives there told me of waking up to see a shadowy spirit standing in an angry stance at the foot of her bed. I was surprised when she told me her address, realizing its proximity to the "help me" incident. She said her whole family and a lot of guests have experienced things there. Undoubtedly, there are many hauntings in these neighborhoods surrounding the railroad.

35. CHINESE RAIL WORKER: BENT AVENUE

Lori, a close friend of mine, has lived with a ghost for many years. She did not tell me of him for quite some time. She's very nonchalant when speaking of him; he's just part of her everyday life. Her home was south of downtown, in a nice neighborhood called Arp Edition that sits on top of a large hill. Lori and Bill lived in this house for thirteen years. Their daughter Kelsey was just two years old when they moved into the house, and immediately she started talking about "the man." She said the man would sing her to sleep at night. She even insisted they set a place for him at the dinner table. Her parents chalked it up to the normal childhood imaginary friend.

Then they started noticing that items would be missing and would turn up in very strange places. They continually found hairbrushes, keys and clothing under the kitchen table. Eventually, they came to realize they had a ghost.

One day, Lori went in to check on her napping daughter, and much to her surprise, she saw the spirit standing next to her daughter's bed. He was an Asian man with shoulder-length hair. He wore a long black coat. He looked fairly young, appearing to be in his early twenties. Surprisingly, Lori felt no fear. Intuitively, she knew he was kind.

Bent Avenue home. *Jill Pope.*

Doing some research, Lori learned that there was a tent camp for Chinese immigrant railroad workers right where her house stood. Talking to their neighbor whose home was directly behind theirs, she learned that they too had a Chinese ghost.

Lori relayed that their Chinese spirit always seemed to be around day or night, and they often caught glimpses of him walking around the house. He loved to turn on the lights and the TV, especially in the middle of the night. One night, they woke up and their bedroom light was flipped on and all three TVs in their house were blaring. Occasionally they would awake and see the spirit standing in the corner of their bedroom. After a couple years, they had a son named Blake. When he got a little older, he spoke of the "China man" tucking him in at night. This is how the family referred of their spirit hereafter.

One night, both Lori and I were visiting their neighbors directly across the street, when the neighbor looked up and said, "Who's at your house?" We could all see the ghost watching us through their picture window. Lori laughed, and we were all blown away.

Once while on vacation, they had asked a neighbor boy to feed their fish. The first day that he came, all the bedroom doors were opened and the aquarium light was on as the family had left them, but the next time he came over, all of the doors were closed and the light was off. He thought this strange but really cringed when on his third visit all the doors were open again and the light was on.

The family decided to move to a new, larger home, and the change obviously disturbed the resident ghost. They began noticing a strange odor in their son Blake's room, and then the carpet on the stairwell was always wet. There were no pipes under the stairwell where the carpet was wet, and the banister was wet too. They had a plumber come and check it out, but he could not determine the cause. It wasn't water; it was more of a slimy, sticky consistency and smelled a little like syrup. It happened several times when the whole family had all been gone for hours. The carpet was soaked when they arrived home. The official term for this substance is ectoplasm.

Eventually, Lori got tired of the mess and simply asked the spirit out loud to stop. She told him they really hated it when he made that mess. As mysteriously as it had all started, it stopped. On moving day, they cleaned out the kitchen cupboards, leaving all the cabinet doors wide open so they could clean inside them. Suddenly, all of the cupboard doors slammed shut at one time!

The ghost had been part of Kelsey's life since she was two years old. With her parents' blessing, Kelsey got out a box and told the spirit to pack his things. Then she took the box along to the new house. One day it was found opened up. His soul is very active in the new house. Lori said he's been hiding Blake's girlfriend's stuff when she comes over, and recently their five-year-old niece saw him in the hallway. He's just part of the family.

36. Sixth Street

The next four stories occurred within a few blocks of each other, taking place between the Riner and Norris Viaducts, in a ghost-ridden neighborhood south of the tracks. A viaduct is basically a bridge that is built in several sections. Viaducts are found in many railroad centers, crossing over the long rail yards and allowing for a steady traffic flow so cars are not continually stopping for trains. The homes situated between these viaducts are part of the original city and were built for railroad workers.

Mothering Ghost, East Sixth Street

Larry, a college student and a friend of my son, rented a small home on Sixth Street. Larry and several friends relayed stories of the home's ghost. The volume on the radio would turn way up by itself. Oftentimes when they were sitting around watching TV, the remote would fly off the mantle and slam to the floor or right onto the couch where they were sitting. They felt like the spirit didn't approve of what they were watching, admitting that their selections may not have been tasteful. As they were leaving, they shut and locked the back door behind them. Larry had forgotten something at the house, so he returned a couple minutes later, only to find the door standing wide open. I could envision a mother figure realizing her child had forgotten something and holding the door open for him when he came back—it's just that this mother was invisible. Always being cautious to shut things off and lock up when he left, Larry was unsettled to find every door wide open, every light on in the house and the stereo blasting when he arrived home one night. The kitchen is a long narrow room. Larry routinely parked his bike inside at the far end of the kitchen. One day he found the bike moved forward a full ten feet.

Larry was hosting a Friday night poker party for the guys. Not wanting to drive after a few beers, Frank and Jason spent the night. They were dreading getting up the next morning because they knew they had a huge mess to clean up. Much to their surprise, the entire place was clean when they awoke. All the cans were thrown away, the spills wiped up, the poker chips put away and the cushions straightened. No one took credit for cleaning. It's as though this spirit is a mother to the boys, cleaning up after them and supervising what they watch on the television. I wouldn't mind having her at my house keeping things clean.

Abused Spirit, West Sixth Street

Liz is currently employed remodeling a house south of the train tracks on Sixth Street near Hebard Elementary School. She has felt and heard a presence from the great beyond many times while working there. It is a female spirit. The disembodied voice regularly says, "Abused but never abused." Liz is not sure what to make of this. She spoke to the landlord who she is working for. He said a woman named Linda had lived in the home for nearly thirty years. They believe it is Linda that is communicating with her.

37. DARKNESS WITHIN DARKNESS: EAST FIFTH STREET

Jose is a member of PHOG, the paranormal investigation group that I have spoken of throughout this book. He is a kind soul who was raised with a strict Catholic upbringing. The maternal side of his family is Yaqui Native American. His grandfather was a native shaman qurandero (healer). This spiritual intuitive healing has carried down through the generations. Jose works in the medical field, carrying on the healing, and is sensitive to his patients' needs as well as the spiritual energies that surround us all. He has had the ability to see things that others can't since he was three years old. The Yaqui people originated in northern Mexico. They have interwoven their native healing culture with Roman Catholic beliefs. When I met Jose, he said he got into paranormal investigations because some intense things had happened in his home growing up. I took that in stride until recently when he told me the specifics of these encounters. The things his family experienced are the most intense that I have been told of. Many of you may be skeptical of these accounts. All I

can say is that Jose expressed genuine emotion while sharing his life story. He feels his faith got him through it.

As a child, his family suffered many hardships. He and his brother were raised by their father. He was a good man, firm in his beliefs, who struggled with tribulations of severe diabetes, including blindness. This forced Jose to take on a lot of adult responsibilities at a young age. The family was close and relied on their faith to get them through some difficult times.

They lived in a small house on Fifth Street, having moved there in 1981 when Jose was eleven. The two boys each had a bedroom in the basement. It was here that they were tormented by something quite evil. The first time Jose encountered this entity he had rushed down into the basement without flipping the light switch on at the top of the steps. It was really dark down there without lights, and there was no light switch at the base of the stairs. He called out to his kid brother to turn them on for him, and about that time, he heard a menacing growl sound in his ear that he likened to a motorcycle being revved. He felt cold on the back of his neck. Filled with fear, he wondered how you see darkness within darkness. He kicked into his fight or flight mode, bolting up the stairs, through the house and rushing out the front door and outside to his father. He was screaming for help and was petrified. When they cautiously went into the home, they found their television volume was turned up full blast and the screen was white snow. His father and a friend searched the house and blessed each room with holy water. Jose did not sleep downstairs for a couple nights.

Jose said a relative brought a Ouija board over one night. He was surprised his dad allowed it. They messed around with it for a while, asking questions, the planchette gliding across the board in response. Jose is afraid it may have opened something up because that is when a lot of the malevolent spirit phenomena began. Many people theorize that spirits thrive on energy, which is why batteries are often drained when spirits are present. Jose feels that with all of the burdens stemming from his father's diabetes and blindness that there was a lot of frustration and anger in the home, which fed their dark entity. Fear breeds fear.

Jose would see shadow figures night and day. One night, he felt a big strong hand shove him down on his bed. Another day he was hanging out in his brother's room watching a basketball game on his television. The reception was not coming in well, and annoyed, he hit the side of the TV. When he did that, he began hearing the growl again. He would hear it on one side, and then suddenly it was on his other side. It kept bouncing around him, and he

did not know where it was from moment to moment. It was terrifying. He prayed his way out of the room.

His father had a guide dog named Colonel to assist him due to his blindness. Colonel was a big black lab. One day when everyone was hanging out upstairs, there was a big crashing sound coming from the basement, as though something had broken. Colonel raced to the top of the stairs and growled but refused to go downstairs. When they did finally go downstairs, they did not find anything broken and could not figure out what caused the loud noise.

Over the years, many of their friends and family members have experienced spiritual phenomena in the home. Perhaps one of scariest events happened to Jose's brother. He was downstairs in his bedroom sleeping. The stairwell was beside his room, and it had the typical storage space under the stairs. During this bloodcurdling experience, he swore that a wolf-like creature with red eyes crept out of the storage area and was growling and stalking him, seeking vengeance from beyond.

Jose's father passed away while he was finishing high school. Jose inherited the haunted home. One night, he had a group of friends hanging out. A couple of them were tired, and they crashed. All of the sudden, they came flying into the kitchen. They had both encountered something that they felt next to their heads, and they heard it say, "Hey babe."

One afternoon, Jose was outside while a couple of his friends were in the house. When he came back in, they were all crouched up on the couch acting hysterical. They had felt something moving around and touching their legs, preying on them.

One night, some of the guys hit the tequila. Jose saw a short creature (but not a child) in the hallway. Because he had been drinking, he didn't say anything. The next morning, one of the guys said, "Wow, that tequila must have really messed with me. I kept thinking I saw a little man in the hall." The other two guys were astonished because they had all seen this little man-like creature too. As they compared notes, they had all seen the exact same thing, tequila or not. They said that he had some transparency to him.

One day Jose's cousin was over. He had never believed in ghosts until he spent time alone in the basement. He prayed for Colonel to come rescue him when he saw one of the shadow people that Jose so often encountered. Colonel did come to his aid, escorting him out of the basement.

Eventually, Jose sold the house. He took several photos before he moved out. The photos were full of orbs. He spoke to the new owner a while later, and he too was having paranormal activity.

I find the paranormal very intriguing, and curiosity is the main reason I take such an interest in spirits. That is not the case for Jose: his main objective is to learn and understand the paranormal so that he can help people who live in fear as he did.

38. LIFE CYCLE: EIGHTH STREET

Arla has lived in many homes in her lifetime. She lived in Cheyenne as a young child and experienced some prevailing paranormal activity. Then in grade school her family moved down south. During her time in the south, she never noticed any spirit activity, but she came back to Cheyenne as an adult and began experiencing paranormal activity once again. I'd like to share some of her childhood events with you. This will allow you to understand why she too is a member of PHOG.

Arla's first memories took place in a small house on Eighth Street near the intersection of Bradley Avenue. There were five children in the family: Arla, Betty, Bobby, Barb and Tammy. The entire family experienced a lot of paranormal activity there. Dishes would fling off the table and smash onto the floor, and the television and the lights would go on and off with no assistance. Even though she was fairly young, Arla recalls her father speaking of an apparition of the upper half of a woman floating at the end of his bed. Her legs were not visible.

The kids had a little dog they named Missy who loved to run and play with them. There was a closet door that spooked the dog. Whenever they would run and play, Missy would stop short when she approached the door, whimpering and scooting backward, obviously frightened. One day the family returned from an errand and could not find Missy. Then they realized she was cowering behind the couch. They had trouble coaxing her out, and she was trembling. Something had terrorized the little pooch in her own home. The entire family seems to be sensitive to spirits, but Arla's mother said of all the places they lived, this home was the most intense. The family members each experienced a negative feeling when they entered the kitchen, a real sense of despair. It was so overwhelming that they did not want to continue walking across the room. They had a space heater in the living room, but it was always frigidly cold right in front of the heater where it should have been really hot. One day while at work, Arla's mother had a disturbing vision of a man murdering his family and burying them in their basement. In an effort to appease her, her husband dug around in the

basement. He uncovered finger bones. Arla's parents asked their pastor to come in to bless and cleanse the house. The activity stopped until moving day. After loading all the boxes and furniture, they thoroughly cleaned the house. Arla's mother closed the curtains before leaving. When they were pulling away, her mother got an eerie feeling. She turned to look back at the house, and one of the curtains was being held off to the side. The malevolent spirit was watching them leave.

When turning in the keys, they spoke to landlord about the experiences they had in the home. He told them that someone had died in the home. He also said that a fortuneteller had previously lived there. Maybe she unleashed something vengeful.

After hearing this story, I drove past the house, and much to my surprise, I was familiar with the home. I realized that a former volunteer for Visit Cheyenne had lived here. I have not been inside but had delivered something to him one time. After he moved out of town, he rented out his house. He was mortified to learn that his renter had committed suicide in the kitchen of his home. The house that stood beside it had blown up due to a gas leak. The man that lived there was literally blown out of house and killed in the explosion. Ashes to ashes, dust to dust.

"Step Child": Van Lennon

Arla's family moved into a home at Seventeenth Street and Van Lennon. They were all stretched out in the living room watching the television together. Her oldest sister, Barb, was tired and went up to the attic bedroom that she shared with her sisters. Barb heard crying at the foot of the bed, she was surprised because she had not heard her coming up the creaky stairs. Barb said "Tammy, what's wrong"? The crying continued. Barb held her covers up, and said, "Come on, Tammy. Get in bed next to me; you'll be OK." She lowered the covers, and no one was there. Again there had been no footsteps going down the old narrow stairs, and no squeaky boards were heard. Bewildered, Barb got up and went downstairs to the family room, saying, "What is wrong with Tammy? She was just upstairs crying." Her parents and siblings gave her a blank look, and then Barb saw that Tammy was fast asleep on the couch. Barb was totally freaked out.

All five children always talked about the little girl on the step. None of them could actually see her, but they felt her presence, and they all spoke of her nonchalantly, almost jokingly. When they were going up or down, they

would walk on opposite sides of the stairs because the little girl was there. One day they were playing and jumping on the stairs. Arla jumped down a few stairs onto the landing, landing not on the open side but rather on the girl's side. Something pushed her hard, and she went tumbling down to the bottom floor. Her tooth went clear through her cheek, and she still has a scar on face to forever remind her of the invisible girl. It wasn't just the kids that were aware of the little girl. Her parents had both seen the apparition. They would catch glimpses of her from the side, but when they looked at her straight on, she was not visible.

Sister Act: Eleventh Street

Arla's family moved into a house on Eleventh Street, just south of Lincolnway Street, when Arla was in fourth grade. She really liked living here and liked her elementary school. Everything in her life felt very positive at this time.

Arla had fallen asleep between her brother and her sister. She woke up in the middle of the night because her sister was crying. She was standing at the dresser, pulling out clothes from the top drawer. "Tammy, what is wrong?" No answer, but then Tammy turned and faced Arla, still crying. Arla groggily said, "We have school tomorrow. Come to bed." As she said this, she tapped the bed beside her to indicate that her sister should climb in, but she realized that she was tapping Tammy, who was asleep right beside her. The girl by the dresser vanished. It seems things got much more intense in the next couple days. Her father woke them all a few nights later. He was really spooked and said, "We are leaving this house right now!" They moved out. Arla still does not know what frightened her father to that extreme. They moved out of state shortly thereafter.

Arla's dad passed away when she was an adult. Twelve years after his death, a picture was taken of Tammy holding her six-month-old daughter. A chilling image of him clearly appears on this photo with the baby girl, his granddaughter.

39. A GRAVE SITUATION: LAKEVIEW CEMETERY

It wouldn't be a complete ghost book without at least one cemetery story. I received an e-mail from Janet, a local woman, a few years back. She said they had a huge dog that was Chesapeake Bay retriever and Mastiff mix.

Lakeview Cemetery. *Matt Idler Photography.*

This dog, Hank, tipped the scales at 180 pounds and was absolutely fearless. In her words, "He would take on the devil himself, and one day, maybe he really did."

They were walking on the sidewalk that bordered the west side of Lakeview Cemetery where the main gate and a small gate are located. The small gate had been left open, and as they passed it, some unseen life force tried to accost the pair. Janet wasn't sure which one of them it was after because she could not see the attacker, but she could intensely feel it. The fight was on. Hank lunged up throat high, biting, growling and jumping at the invisible aggressor. Janet struggled to hold onto Hank's leash and pulled out in the street. Hank was fighting for his life and his master's. It was a grave situation. Cars stopped to watch the strange sight. Janet finally managed to drag Hank across the street, and the entity retreated. The grueling fight lasted over five minutes.

Janet went on to say that she told her neighbor about the bizarre attack. He said the same thing had happened to him and his German Shepard, and he said his dog never liked that area either and had gotten in an intense fight with "something." Neither of them ever took their dogs anywhere near the cemetery again. They agreed that this is why cemeteries have a fence around them: to keep something in.

CONCLUSION

The majority of the spirit encounters I've shared are harmless events, and most of us cohabit with the spirits just fine. In death, as in life, some spirits are not kind-hearted, even vengeful, but there's more good than bad in the world.

Much of what we feel or sense is our own loved ones that have passed on, staying near and watching over us, surrounding us with their love and guidance. Be kind to the spirits because someday you will be one too. I hope that all your encounters with ghosts are friendly. Happy hauntings.

Depot portico. *Envy Photography.*

Either the wallpaper goes, or I do.
—Oscar Wilde (1854–1900), his final words on Earth

BIBLIOGRAPHY

Adams, Judith. *Cheyenne: City of Blue Sky*. Northridge, CA: Windsor Publishing, 1988.

Cheyenne Centennial Committee. *Cheyenne: Magic City of the Plains*. Cheyenne, WY: Cheyenne Historical Committee, 1967.

Dial, Scott. *A Place to Raise Hell: Cheyenne Saloons*. Boulder, CO: Johnson Publishing, 1977.

Dubois, William, III, James L. Ehernberger and Robert R. Larson. *Cheyenne Landmarks, Laramie County Chapter*. Wheatland, WY: Wyoming State Historical Society, 1976.

1868–2012 Cheyenne City Directories. Laramie County Library System, Genealogy Department.

Field, Sharon Lass, ed. *History of Cheyenne Wyoming*. Vol. 2. Dallas, TX: Curtis Media Corp., 1989.

Flynn, Shirley, and William Dubois. *We've Worked Hard to Get Here: The First One Hundred Years of the Greater Cheyenne Chamber of Commerce*. Cheyenne, WY: Cheyenne Chamber of Commerce, 2007.

Munn, Debra. *Ghosts on the Range: Eerie True Tales of Wyoming*. Helena, MT: Riverbend Publishing, 1991.

Nelson, Ann. "The InterOcean: A Story of an Early Wyoming Hotel." *Wyoming Tribune Eagle*, August 4, 2002.

O'Neal, Bill. *A Biography of the Magic City of the Plains: Cheyenne*. Austin, TX: Eakin Press, 2006.

Stelter, Gilbert A. *Annals of Wyoming*. Cheyenne, WY: Wyoming State Archives and Historical Department, 1967.

Trenholm, Virginia Cole, ed. *Wyoming Blue Book*. Vol. 3, 50th Legislature Centennial Edition. Cheyenne, WY: Wyoming State Archives and Historical Department, 1990.

Weidel, Nancy. *Images of America: Cheyenne, 1867–1917*. Charleston, SC: Arcadia Publishing, 2009.

Wyoming State Archives. Newspaper microfiche and photos.

Wyoming Tribune Eagle article on St. Marks Church. October 28, 1978.

ABOUT THE AUTHOR

Jill Pope is the director of operations at Visit Cheyenne, the Convention and Visitors Bureau. She has managed and co-written the Cheyenne Street Railway Trolley Ghost tours for eleven years. These popular tours sell out each year with some customers traveling from neighboring states to experience the popular tours. It is Jill's passion to document people's spiritual encounters in Cheyenne, Wyoming, and the surrounding area, delving into the history of the haunted locations and making sense of the paranormal experiences that occur there. Over the past six years, she has collaborated with a few paranormal investigation teams to meld scientific explorations with people's experiences and lore. Some of the stories she tells have been passed on for years, while many were relayed directly to her by the individual who experienced the paranormal event.

Jill is also an artist, using several mediums from sculpting, stained glass and painting. Her work can be seen on the streets of Cheyenne where two of her eight-foot-tall painted fiberglass boots are displayed in the depot plaza. The boots are part of the "These Boots Are Made for Walking" city-wide collection. The names of Jill's boots are *Don't Feed the Animals* and *Milestones: The Chamber of Commerce 100th Anniversary*.

Jill is married to Darin Pope and is the mother of two children and three stepchildren. She also has two grandchildren who are the light of her life.